Nature and Imagination

Nature and Imagination

THE WORK OF ODILON REDON

Michael Wilson

Phaidon · Oxford

Phaidon Press Limited, Littlegate House,
St Ebbe's Street, Oxford

First published 1978
Published in the U.S.A. by E. P. Dutton
© 1978 Phaidon Press Limited
Text © by Michael Wilson
All rights reserved

ISBN 0 7148 1849 6
Library of Congress Catalog Card Number: 78-55002

Printed in Great Britain by Waterlow (Dunstable) Ltd.

List of Plates

Short Bibliography

Bacou, Roseline. *Odilon Redon* 2 vols. Geneva 1956.

Berger, Klaus. *Odilon Redon Fantasy & Colour*, translated from the German by Michael Bullock, London. 1st German edition Cologne 1964.

Hobbs, Richard. *Odilon Redon* London 1977.

Mellerio, André. *L'Oeuvre graphique complet d'Odilon Redon* Paris 1913.
Odilon Redon, peintre, dessinateur et graveur Paris 1923.

Redon, Arï. *Lettres de Gauguin, Gide, Huysmans, Jammes, Mallarmé, Verhaeren . . . à Odilon Redon*, with notes by Roseline Bacou, Paris 1960.

Rewald, John. *Odilon Redon* in *Odilon Redon, Gustave Moreau, Rodolphe Bresdin*. Exhibition catalogue of The Museum of Modern Art, New York 1961.

Sandström, Sven. *Le Monde Imaginaire d'Odilon Redon—étude iconographique* Lund 1955.

WRITINGS BY REDON

A soi-même, Journal (1867-1915). Notes sur la vie, l'art et les artistes, with an introduction by Jacques Morland, Paris 1922. New edition Paris 1961.

Lettres d'Odilon Redon 1878-1916. Publiées par sa famille avec une préface de Marius-Ary Leblond, Paris and Brussels 1923.

Lettres de Vincent Van Gogh, Paul Gauguin, Paul Cézanne, J-K Huysmans, Léon Bloy, Elémir Bourges, Milos Marten, Odilon Redon, Maurice Barrès à Emile Bernard. Tonnerre 1926, 2nd edition Brussels 1942.

Introduction

For every person who has heard of Odilon Redon there will be dozens who are familiar with the names of Gauguin, Van Gogh and Cézanne. In British galleries Redon is scarcely represented at all and he remains hardly less obscure now than he was in his own lifetime. And yet his achievement and his significance to the art of our own century has been widely acknowledged by critics and artists. In 1912 André Salmon opened his study of contemporary painting, *La Jeune Peinture Française*, with this testimony to Redon: 'Allow me to set at the head of this work praise to a liberating master, to whom everyone owes as much as to Delacroix, Courbet, Manet, Renoir, Seurat, Toulouse-Lautrec, Van Gogh, Degas, Cézanne, etc. I mean Odilon Redon.' Marcel Duchamp placed Redon before Cézanne as a point of departure for subsequent painters. Indeed in his latter years before the First World War, although he refused to set himself up as a teacher, Redon found himself surrounded by an admiring group of young painters which included Maurice Denis, Bonnard, Vuillard and Matisse.

No one who has seen and enjoyed works by Redon, particularly his late pastels and oils, will deny their astonishing originality and freedom, or fail to acknowledge Redon's stature as an artist. Why then his obscurity? Why is it that he is overshadowed by his more famous contemporaries? It is well known that Van Gogh and Gauguin, like the Impressionists, were ignored and scorned, but recognition, when it eventually came, was widespread and enthusiastic. The evidence for it is in our galleries and on the walls of countless homes. Redon has never been popular except among relatively small groups, consisting largely of artists and intellectuals. In recent years a revival of interest in Symbolism has attracted more attention to him, but without dissipating the myths that surround and obscure his achievement. He remains the creator of nightmares and monsters, of ghastly and perhaps puerile fantasies, and it is at this point that critical analysis stops short and inclines instead towards the healthier and more accessible canvases of Gauguin and Cézanne. But what then becomes of Redon's extraordinary technical virtuosity as a lithographer, and the visual splendour of the flower pictures? The issue of content and meaning still stands as a fearful and difficult barrier between the public and Redon's pictures, prohibiting a just appreciation of his powers as an inventor of visual images.

This has always been the case. In his own day Redon's work was felt to be not only difficult but, in an undefined way, seditious, and his most vocal defenders, writers and artists of the Symbolist camp, only contributed to this impression by relating his work to their own themes and theories.

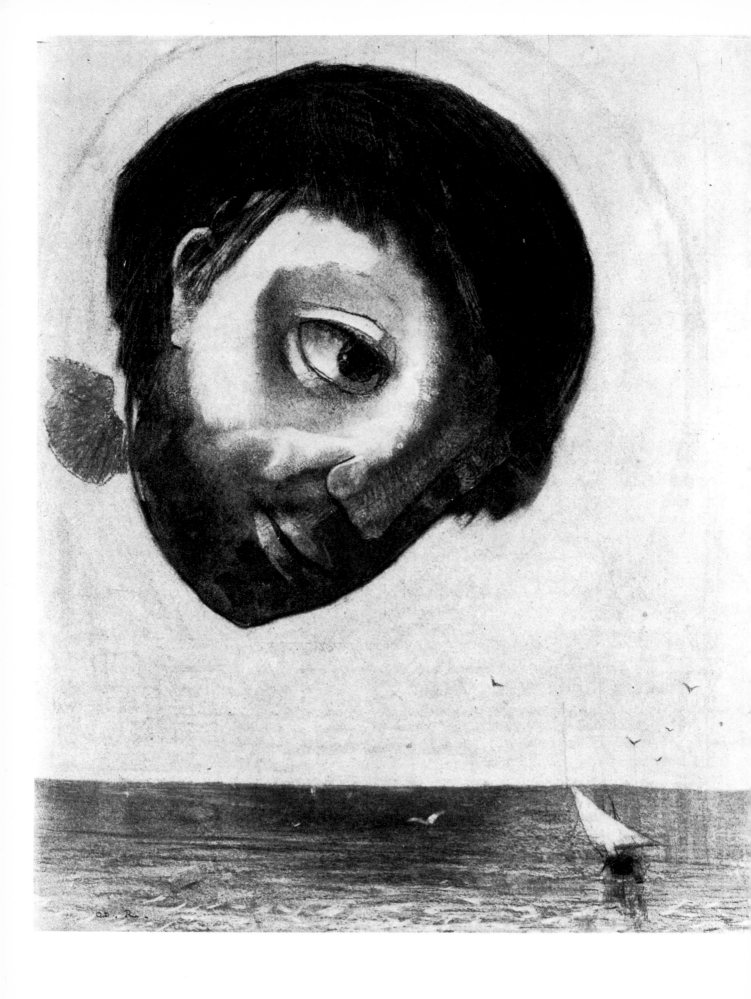

Redon was involuntarily identified with the avant-garde of his day. The public failed to accept him as an artist in his own right and he has in consequence remained ever since inextricably bound up in the history of the Decadents and the Symbolists.

There is another reason for his obscurity, in the past and now. For the first forty years of his life he swam against the artistic current of the time. Born in 1840, the same year as Monet, a year before Renoir, Redon was of the Impressionist generation, but unlike Cézanne, Gauguin and Van Gogh, who with him forged new paths late in the century, he never passed through an Impressionist phase or flirted with the style. During the third quarter of the nineteenth century, years which in France saw the triumphant emergence of Realism and Impressionism, Redon remained in Bordeaux and on his father's estate nearby, pursuing his unorthodox and solitary training as a graphic artist. Not until 1879, with the publication of his first lithographic album *Dans le Rêve*, was his existence acknowledged by public or critics. But it was not merely through lack of opportunity that Redon failed to participate with the Impressionists. He approved of their rejection of stale academic formulae and the return to close observation of nature, but found the ceiling of Impressionism 'too low'. In 1868 *La Gironde*, a Bordeaux newspaper, published three articles by him on the Paris Salon, which included that year works not only by Courbet and Manet, but by three unknowns: Pissarro, Jongkind and Monet. Courbet's Realist theories, he complained, left no room for thought, inspiration and genius, and in Manet he noted an 'absence of moral life, that intimate and inner life which a painter trans-

lates in those felicitous moments when he expresses himself with particular intensity'. Notwithstanding the fidelity with which these painters had reproduced the exterior world, Redon concludes, 'those who remain within these narrow limits commit themselves to an inferior goal'. In 1880, writing on the Impressionist exhibition of that year, he reaffirms his views, acknowledges the truth of their colour but again objects to their concentration on an 'external ideal'. The future, on the contrary, belongs, he writes, to 'the subjective world'.

Just a glance at Redon's work of the 1870s will confirm his complete independence from naturalism. Roughly contemporaneous with the first Impressionist show of 1874 is the charcoal drawing *Winged Head above the Waters* (Fig. 1). Although far from the sophistication and subtlety of his later lithographs, it already shows Redon juxtaposing strange elements to create an unnatural and suggestive image. Time and space remain uncertain and ambiguous and the charcoal, far from being tied to any limited imitative function, is used to full effect as a means in itself of creating resonant textures and contrasts. An appreciation and exploration of the medium, which in naturalistic art is incidental, forms here the very basis of Redon's achievement.

In the 1880s Redon applied himself to the production of lithographic albums, a means suggested by Fantin-Latour of reproducing his art and making it known to a wider audience. Recognition, however, came not from the general public who frequented the Salon exhibitions, nor from the supporters of Impressionism, but from the renegade literary set who had forsaken Zola and naturalism for the more esoteric ways of Decadence. Redon was in need of support and the enthusiastic reception awarded him by writers such as Joris-Karl Huysmans and Emile Hennequin marked a turning point in his career. But this

1. *Winged Head above the Waters*. About 1875. Charcoal, 45.4 × 37.5 cm. (17⅞ × 14¾ in.) The Art Institute of Chicago

9

association with literary circles militated against him until the end of the century: he was misrepresented by people who were not entirely receptive to his aims as an artist, and was consequently misunderstood by the public.

The story of Redon's achievement, however, would not be remarkable if it stopped here. He was over forty before his work was noticed at all. He was sixty when he abandoned the black and white of his graphic work and turned instead to pastels and oils, producing in the fifteen years before his death in 1916 colour works of extraordinary freedom and joyfulness. During the 1890s contact with younger painters such as Emile Bernard and the Nabis helped to emancipate his art and open the way to expressive colour. And concurrent with this expansion of technique is a momentous transformation of mood from the sadness and horror of the lithographs to a new optimism, which finds expression in canvases of flowers, nudes and such mythological subjects as the Chariot of Apollo.

Odilon Redon may be an example of an artist born too early, who had to bide his time before a public was prepared to look at his work and his talent could freely blossom. If so, it is all the more remarkable that, after the long years of obscurity and dark imaginings, he was still able to undergo such a metamorphosis. The image that comes readily to mind, of a butterfly emerging from a chrysalis, is perhaps, in Redon's case, entirely appropriate. In view of what can be regarded as no less than a miracle, it yet remains unfortunate and indeed unjust that Redon's reputation has still not quite recovered from the mismanagement of a group of over-enthusiastic littérateurs of the 1880s. No way is better to redress the balance than to look again at his life and works.

In a letter of 1894 Redon wrote that 'the artist . . . will always be a special, isolated, solitary agent, with an innate sense of organizing matter.' Without a doubt the degree of Redon's independence and individuality is exceptional and must not be underestimated, but no artist works within a vacuum. Unusual though his art is, it would be unrealistic to regard it as the unalloyed product of an artist working in complete isolation. Yet what is extraordinary in Redon's career is the extent to which he was able in the crucial years of his youth to escape the prevailing influence of naturalism.

The current history of nineteenth-century painting in France still traces a single line of development from Delacroix via Courbet and the Barbizon School to Impressionism. It affirms the emergence of a painting based on colour as opposed to line, and the rejection of traditional subject-matter drawn from classical history, mythology and the Bible in favour of themes from contemporary life and the naturalism of *plein air* landscape painting. A later chapter in the story tells of the questioning of naturalism as a goal and the emergence in the 1880s of new modes of vision, of Post-Impressionism and Symbolism. But, to point to just one flaw in this argument, Delacroix, the liberator of colour, ended his life lamenting the new artistic current. 'Realism', he wrote in 1860, in an entry for a proposed dictionary of the arts, 'should be defined as the antithesis of art'. The purpose of art, he asserted, was not to imitate nature but to give access, via the imagination, to the ideal world which exists within the artist. 'It is thus of far greater importance', he wrote, 'for the artist to approach closely the

2. *Self-portrait*. 1867. Oil, 34.9 × 23.8 cm. (13¾ × 9⅜ in.) Private Collection

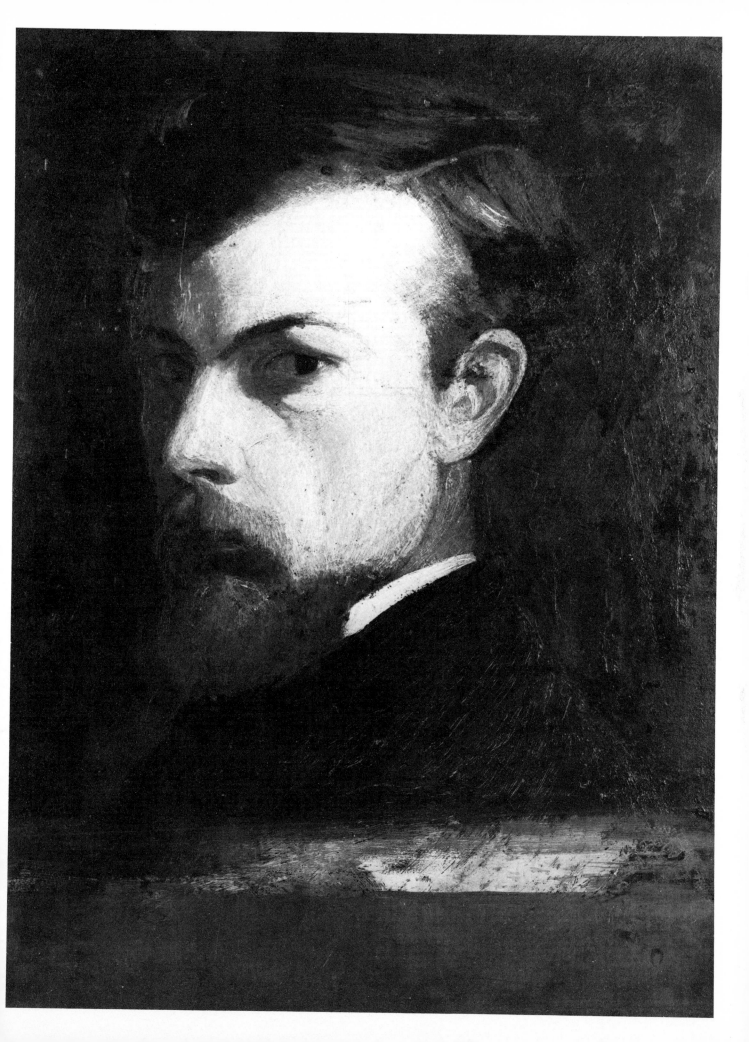

ideal he carries within him, that is unique to him, than to reproduce, even with force, the fleeting ideal which nature can present.' In old age Delacroix became a recluse and a misanthrope, totally out of sympathy with the developments of the period.

Courbet's realism, while drawing stylistically upon Delacroix, was essentially a reaction to the ideals and fantasies of Romanticism. Yet Delacroix did not lack artistic heirs. In the 1860s, when the Impressionists were first attracting public attention with their uncompromising landscapes, Gustave Moreau, a young painter under the spell of Delacroix, Chassériau and the Primitive and Byzantine art of Italy, was exhibiting at the Salon richly coloured and ornamented interpretations of such mythological subjects as Orpheus, and Oedipus and the Sphinx. His work was much criticized and after 1880 he ceased to exhibit at the Salon. Nevertheless he was made a member of the Academy and at the Ecole des Beaux-Arts taught such painters as Matisse and Rouault, thus establishing a direct line of descent from Delacroix to the Fauves. Another painter to escape the influence of Realism was Puvis de Chavannes, who in his decorative murals, painted in broad areas of flat colour, anticipated the effects later achieved by Gauguin and the Synthetist group at Pont-Aven. And to these heirs of Delacroix, who constitute the alternative course of nineteenth-century painting after 1850, may be added Redon himself, who avowed that it was to Delacroix that he owed the first awakening of his flame. It is arguable that Gauguin and his Symbolist successors owed at least as much to these painters as to the Impressionists, who bequeathed to them only their palette of bright unmixed colours.

Redon's provincial background can therefore be seen paradoxically as a benefit to his development. From a visit to Paris at the age of seven he retained memories of dramatic

Romantic paintings, works of violence and excess. At Bordeaux he saw not the new productions of Impressionism but exhibitions containing works by Delacroix, Moreau, Corot and the Barbizon painters. In the landscapes of the Barbizon School he found not the stale imitation of nature, but a combination of observation and feeling, and Redon himself went to Barbizon to work in the summer of 1875. In Redon's view Millet and Corot succeeded where others failed because they combined the essential qualities of painter and thinker. He recorded in his journal Corot's advice to him: 'Beside a certainty place an incertainty,' words which sum up Redon's own approach to nature and his desire to juxtapose known reality to the projections of the subconscious.

Alongside Redon's early experience of painting must be placed his inheritance of Romantic ideas. It was not only through art itself that Redon became the heir of the Romantic generation; it was also through the written and the spoken word. He was introduced to Baudelaire's *Fleurs du Mal* on its appearance in 1857, and he later became acquainted with both Baudelaire's art criticism and Delacroix's writings. And to these Romantic testaments must be added the contact with teachers and acquaintances of an older generation. In the 1870s, after he had taken up residence in Paris, he came to frequent the salon of Madame de Rayssac, where he met men who had participated in the events of the 1830s and known such key figures as Victor Hugo, Alfred de Musset and Delacroix. One of these was the painter Paul Joseph Chenavard, a one-time intimate of Delacroix, from whom Redon was able to glean precious anecdotes about the champion of Romanticism. There also he met younger men, such as the painter Fantin-Latour and the composer Ernest Chausson, who became a close friend. Nevertheless the effect of this episode was

above all to reinforce Redon's association with concepts regarding art that belong properly not to his generation, but instead either to the first half of the century or to its last decades.

In a note of 1887 Redon lists those three sources which he regards as the well-springs of art: Tradition, the legacy of art, containing 'the entire thinking and moral life of humanity'; Reality or Nature, 'outside of which our own ambition to create remains in a state of dream, of abstraction'; and Personal Invention, 'the original intuition that combines and summarizes everything, seeking support in the past and in the present in order to give to the contemporary world a new organization'. These principles are quintessential to Romanticism. The second and third form in effect the Romantic equation: Nature is the raw material, Baudelaire's Storehouse of Images, Delacroix's Dictionary of Forms, which must be infused by the spirit of the artist. Baudelaire attributed this action to imagination, 'the Queen of the Faculties', and Redon follows him when he speaks of imagination as 'that sovereign who suddenly opens up to us magnificent, astonishing delights and subjugates us. She has been my guardian angel.' It is the transformation wrought on the objective world by the artist's own temperament that distinguishes true art from that of the Realist. Art which only reproduces reality is the expression of a materialist ethic and neglects the inner life, the vague and undefined life of the unconscious. 'The artist', Redon asserts, 'submits from day to day to the fatal rhythm of the impulses of the universal world which encloses him, continual centre of sensations, always pliant, hypnotized by the marvels of nature which he loves, he scrutinizes. His eyes, like his soul, are in perpetual communion with the most fortuitous of phenomena.' Understanding depends upon the eye,

but by this Redon means not merely mechanical sight but a kind of vision: 'to see is to seize spontaneously the relation of things.' Redon hopes to evoke in his art, by very deliberate means, a sense of mystery equivalent to that which he feels in the presence of nature. 'I have placed there a little door opening on to the mysterious. I have made stories.' Beyond this Redon will not explain himself. Here again he follows in the Romantic tradition. Art cannot be analysed, is not subject to systems. Those who truly know its pleasures 'yield with docility, without the help of sterile explanations, to the secret and mysterious laws of the sensibility and the heart'. There is more than a suggestion of mysticism in Redon's remarks on man's communion with nature, a mysticism which has its roots in German Romanticism of the late eighteenth century. It is this, together with his belief that art, 'la Portée Suprême', does not instruct but instead exalts and redresses the spirit, that constitutes Redon's idealism and sets him in opposition to positivist theories of social art.

Romantic again is his notion of the artist as one removed from society and, by virtue of his essential characteristic of openness, destined to suffer. Retiring and shy as a child, Redon remained so as a man, who yet had to struggle against misrepresentation and adverse criticism. He saw in the fate of other neglected and abused artists, such as Antoine Chintreuil, Rodolphe Bresdin and Berlioz, a reflection of his own, and accepted it as inevitable that innovatory art should pass unappreciated. This in turn confirmed in Redon an inclination to solitude, to introspection and sadness—the *douleur* that is the distinguishing feature of the Romantic artist—which served only to reinforce the darker and more melancholy aspects of his graphic work. Not until critical acclaim and the companionship of artists changed these circumstances of his existence

was he able to blossom into colour and dispel what he described in 1898 as 'the black fumes of Romanticism'.

A provincial background is hardly sufficient in itself to explain Redon's rejection of naturalism and his early and marked inclination towards idealist notions of art. Before his encounter with the ageing Romantics of Madame de Rayssac's salon, Redon had already undergone a kind of initiation into Romantic ideals in Bordeaux, where his artistic training began. While still at school he studied drawing under a local artist, Stanislas Gorin, a pupil of Jean-Baptiste Isabey. A passionate admirer of Delacroix, Gorin instructed Redon in the first principles of Romantic art: to make every line an expression of both sensibility and reason, to be himself and to distrust all rules and formulae. It was at his father's insistence that on finishing school Redon turned to architectural studies, but he failed to be accepted for the architectural class of the Ecole des Beaux-Arts in Paris and so remained in Bordeaux, where for a year he studied sculpture. More significant to his artistic development, however, was his acquaintance with the botanist Armand Clavaud, whom he met in 1861. It was Clavaud who introduced Redon to the writings of Flaubert, Edgar Allan Poe and Baudelaire. He was an admirer of Spinoza's pantheism and was acquainted with Hindu poetry, Greek, medieval and Indian art. For Redon he represented the rare union of scholar and artist, for whom a provincial existence had proved no obstacle to the pursuit of knowledge. He later remarked that he owed to Clavaud's teaching the first blossoming of his spirit.

Redon's development was in effect interrupted when in 1864 he moved to Paris to study painting at the Ecole des Beaux-Arts. The liberty he enjoyed under Gorin—studying from nature and inventing fantasies—scarcely prepared him for the regimen he was to experience in the studio of Jean-Léon Gérôme. The account he has left us of this in *Confidences d'Artiste* deserves to be quoted at length since it shows to what extent Redon felt himself different from others and in opposition to academic art and instruction.

I was tortured by the teacher. Whether it was that he recognized the sincerity of my sincere desire to study, or whether he saw in me a shy individual of good will, he manifestly sought to inculcate in me his own way of seeing things and to make of me a disciple—or to make me disgusted with art itself . . . He ordered me to enclose within a contour a form which, for my part, I saw vibrating. On the pretext of simplification (and why?) he made me shut my eyes to light and neglect the vision of substances . . . The teacher utterly failed to appreciate my natural gifts. He did not understand me in any way whatsoever. I saw that his eyes were voluntarily closed to everything which mine saw. Two thousand years of evolution or transformation in the way we interpret vision are a small thing in comparison with the divergence between our two opposed souls. There was I, young, sensitive and inescapably a child of my time, listening to obscure rhetoric based in some way or other upon the works of a past age. This teacher would vigorously draw a stone, the shaft of a column, a table, a chair, some insignificant inanimate object, a rock and the whole of inorganic nature. The pupil saw only the expression, the welling up of feeling triumphing over the forms. Impossible to establish any link between the two, impossible to establish an alliance. Submission would have required the pupil to be a saint, which was impossible.

In the 1860s an artist who looked for public recognition had no alternative but to submit work to the Salon Jury and to accept its judgement on him. The art establishment, the Academy, not only dictated, by the appointment of teachers, the form of instruction artists received at the Ecole des Beaux-Arts, it also held their fate in its hands by controlling the chief means of exhibition—the Salon. In rejecting the system and its values Redon committed himself to obscurity. Not until the 1880s, after the Impressionists had forged the way with their independent exhibitions, did alternative means of showing work become readily available.

Redon looked instead to the guidance and instruction of a man who had already turned his back on the official art world and lived at Bordeaux in near penury: Rodolphe Bresdin. Bresdin's contempt for bourgeois taste, his individualism and bohemian life-style served as an important example to Redon, and a consolation in the face of his own difficulties. Twenty years older than Redon he pursued his own path, without recognition, and advised Redon to do likewise. His work consisted of fantastic landscape compositions crowded with detail and sinister images, like *The Comedy of Death* (Fig. 3), today one of his most famous lithographs. A graphic artist himself, he introduced Redon to the prints of Rembrandt and Dürer, which came to form for Redon a major source of inspiration. Here and in Bresdin's own work Redon found examples of nature transformed by imagination, a blend of imitation and invention that he regarded as the hallmark of his own work. *The Ford* (Fig. 4) of 1865, which is signed by Redon 'élève de Bresdin', shows how closely he depended on Bresdin's example at this time. Tiny figures are juxtaposed against a strange landscape of vast scale. Sharp contrasts of tone are achieved by a variety of hatching techniques, the whole surface being

covered with dense linear patterns. Lacking still is the strange and original imagery of Redon's more characteristic work, the range of texture and the breadth of treatment.

During his training in Bordeaux and Paris Redon had painted studies from nature and some subject compositions, but from the moment of his contact with Bresdin black and white became his prevalent means of expression. Black he later wrote of as 'the agent of the spirit', and his early rejection of colour can be seen as the rejection of imitative, materialist painting for an idealist art. As a painter he would perhaps have had difficulty in avoiding the influence of naturalistic or academic art. He turned to colour and to painting only after establishing his independence. And in adopting black and white he allied himself to a graphic tradition which in the nineteenth century had proved itself far more liberal and experimental than that of painting. Apart from the overwhelming example of Goya, Delacroix had produced some of his most fantastic images, the illustrations to Goethe's *Faust*, as lithographs. French caricaturists like Gérard Grandville had often, for satirical ends, made use of distortion and monstrous inventions, such as Redon adopts for more ambiguous purposes. In Daumier, too, a free graphic style contributes to the expressive horror and pathos of his images. The imaginative inventiveness that Redon sought was in the 1860s tolerated only in popular illustration and caricature, yet painters also often proved themselves more experimental in their drawings and studies. In his late etchings and lithographs Corot caught the atmosphere of his pastorals without their cloying sweetness, and Millet in the 1850s developed a drawing technique which avoids line and anecdotal detail, generalizes form and through tonal balances alone creates expressive atmospheric effects.

In deciding to devote himself almost ex-

15

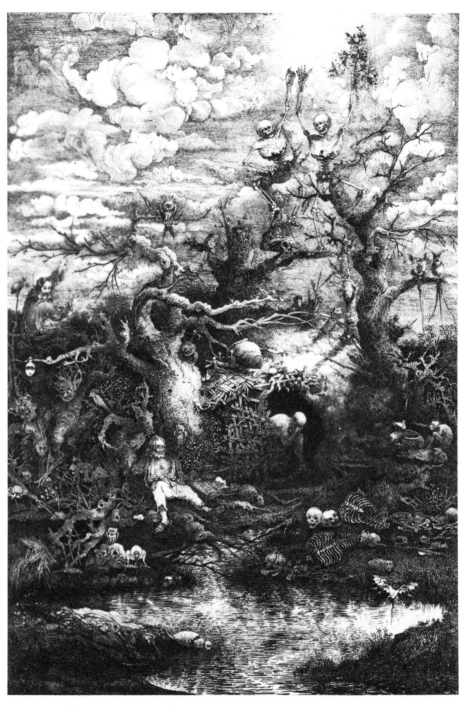

3. Rodolphe Bresdin (1822–85): *The Comedy of Death*. 1854. Lithograph, 21.9 × 14.9 cm. (8⅝ × 5⅞ in.)
London, British Museum

4. *The Ford*. 1865. Etching, 18.1 × 13.7 cm. (7⅛ × 5⅜ in.)
The Hague, Gemeentemuseum

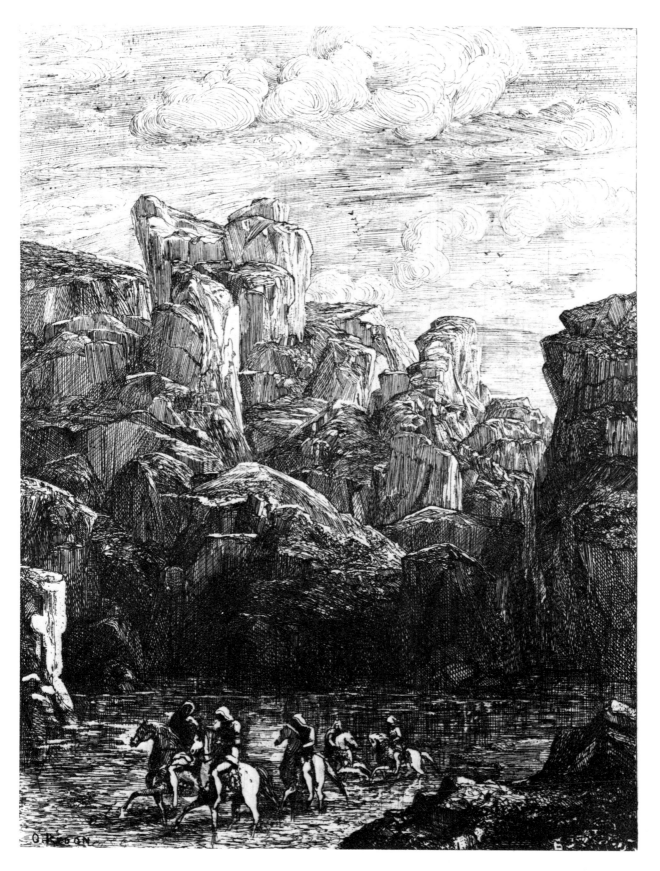

O'KEON.

clusively to graphic media, Redon was choosing the course that would best allow him to give expression to the mysterious and the indeterminate. The graphic work of the period provided examples of how black could be used to give visual form not to the material world but to its counterpart, the world within the artist, and gave hints of the technical means by which this might be achieved.

The Early Graphic Work

Redon's first lithographic albums reproduce for the most part ideas and images which occur originally in the charcoal drawings of the 1870s, produced in isolation at Peyrelebade, the family estate in the Medoc, north of Bordeaux, where he continued to spend each summer after his move to Paris. Although the origins of these drawings can be traced to such sources as contemporary caricature, children's books and the art of the past, the remarkable thing about them is their originality. The subjects of *Mephistopheles* (Fig. 5) or *Head of a Martyr on a Platter* (Fig. 6) may derive from Romantic literature or popular mythological and religious themes —the severed head alludes to Saint John the Baptist—but Redon's drawings are far from being illustrations. He avoids any precise identification that would restrict the resonance of the image itself. *Mephistopheles* is subtitled *Madness*. Unlike caricature, these drawings serve no satirical or social purpose, and so the graphic medium can be explored for its own sake, creating effects that mystify and do not define. *The Head of a Martyr* already shows Redon's mastery of abstract design, his ability to reduce his image to simple geometrical shapes and to powerful contrasts of light and shade, not to model form but rather to render his subject less natural and less familiar.

Abstraction is for Redon a means and not

5. *Mephistopheles* (*Foolishness, Madness*). About 1877. Charcoal, 34.9 × 31.1 cm (13¾ × 12¼ in.) Paris, Louvre (Cabinet des Dessins)

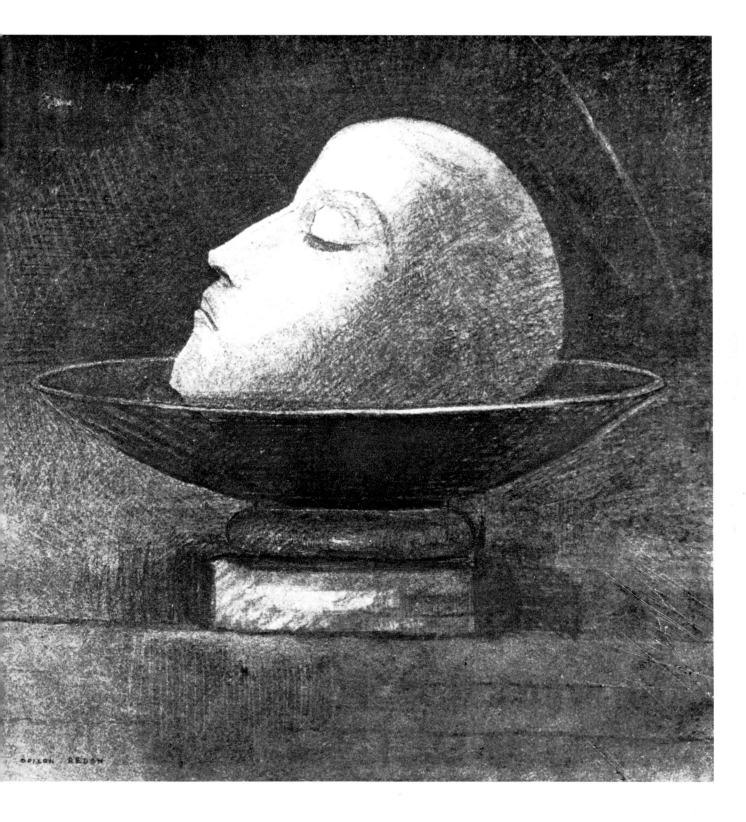

6. *Head of a Martyr on a Platter*. 1877. Charcoal, 37.1 × 35.9 cm. (14⅝ × 14⅛ in.) Otterlo, Rijksmuseum Kröller-Müller

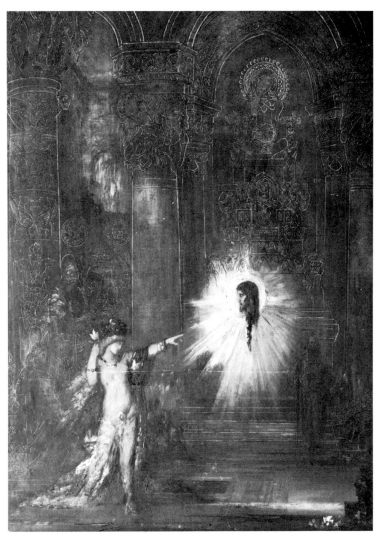

an end in itself. His images are figurative. Heads, eyes, animals and plants are the familiar and recognizable properties of his pictures, but their effect depends upon the context in which they are placed. The known and the unknown are set in a novel and startling relationship. The results are never obvious or banal. *Vision* (Fig. 8), a lithograph from Redon's first series, *Dans le Rêve*, which appeared in 1879, recalls Gustave Moreau's painting, *The Apparition* (Fig. 7), one of his many works based on the story of Salomé. But while Moreau's vision consists of a severed head appearing within Herod's palace, Redon shows two figures approaching an opening between columns, where hovers a spherical eye-ball of enormous size. The rational three-dimensional space of the stage-like foreground is juxtaposed against a truly fantastic and inexplicable vision, tending on abstraction. There is no anecdote, no myth, only a shocking and mystifying enigma.

The appearance of *Dans le Rêve* went unnoticed, but its publication was shortly followed by two small exhibitions of charcoal drawings, which marked for Redon the beginning of his public career. The first was held in 1881 in the offices of *La Vie Moderne*, a weekly review, the second a year later on the premises of the newspaper *Le Gaulois*. Response was slight but included the praise of two writers whose support was to have great consequences for Redon. In his review of the 1882 exhibition Emile Hennequin recognized in Redon a kinship with the new wave of Decadent writers who had rejected the precepts of Zola's naturalism. The other writer to respond enthusiastically to Redon's work was one of these rebels, Joris-Karl Huysmans, who likewise found in Redon's visionary art an exciting alternative to the current vogue

7. Gustave Moreau (1826–98): *L'Apparition*. 1876. Watercolour, 105 × 72 cm. (41⅜ × 28⅜ in.) Paris, Louvre (Cabinet des Dessins)

8. 'Vision', *Dans le Rêve*. 1879. Lithograph, 27.3 × 19.7 cm. (10¾ × 7¾ in.) London, British Museum

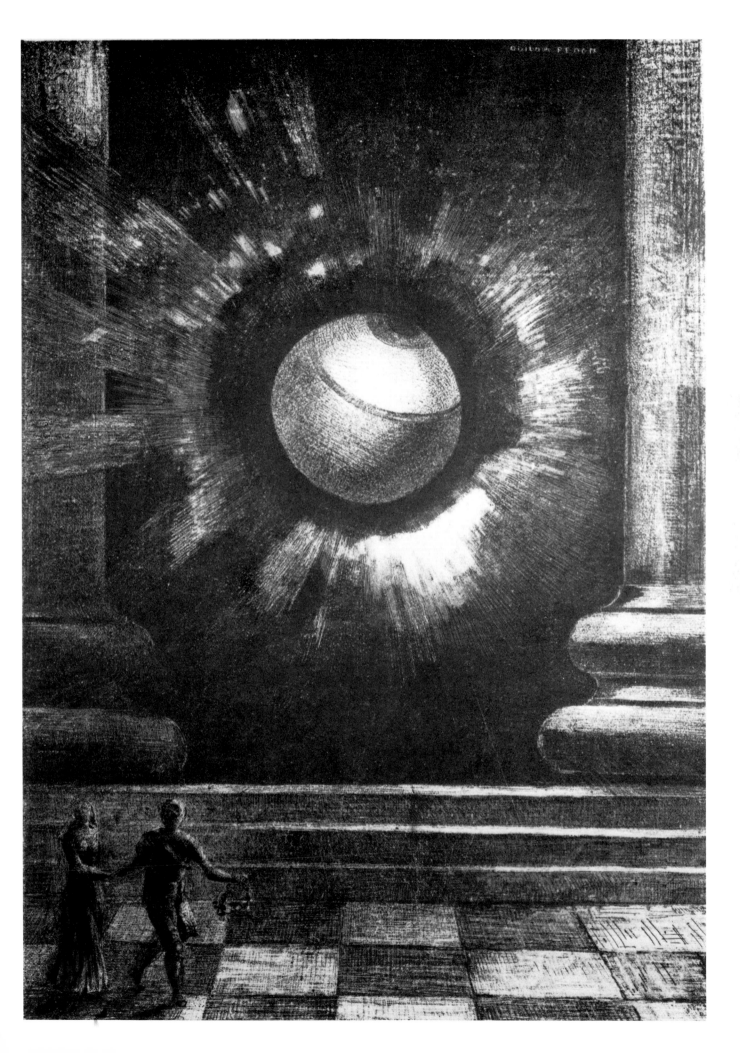

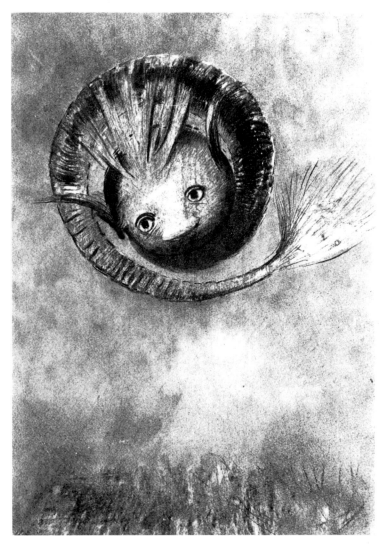

for naturalism. At the moment of Huysmans's encounter with Redon and his art he was himself composing a novel that would demonstrate his independence from Zola, his one-time mentor. When it appeared in 1884 *A Rebours* was hailed as the manifesto of Decadence. Exhausted and debilitated by a life of hedonistic pleasure, the young hero, des Esseintes, retires disgusted from the world to devote himself in the solitary confinement of his home on the outskirts of Paris to the cultivation of refined and aesthetic sensations. Among the bizarre and synthetic means he adopts in his flight from nature to stimulate his fevered mind are the literature of the Roman Decadence, the obtuse and tortured prose of medieval theologians, monstrous and unnatural plants, and those products of art of his own period that had eschewed naturalism: the poetry of Baudelaire and Mallarmé and the pictures of Moreau, Bresdin and Redon. What appealed to Huysmans were Redon's monstrous forms, the combination of unlikely elements; amongst des Esseintes's private collection of Redon drawings, we find one of 'a horrible spider with a human face lodged in the middle of its body' (Fig. 10). In describing Redon's work Huysmans made explicit the horror he found suggested there. He applauded and defined what he regarded as the perverse products of a demented mind. Like Hennequin, who discovered in Redon the expression of 'our most profound and modern ideas about corruption, depravity and guile', Huysmans esteemed Redon less as a visual artist than as a fellow partisan of Decadence. 'These drawings defied classification,' he wrote in *A Rebours*, 'most of them exceeding the bounds of pictorial art and creating a new type of fantasy, born of sickness and delirium.'

9. *Fantastic Monster*. 1880–5. Charcoal, 47.9 × 34 cm. (18⅞ × 13⅜ in.) Otterlo, Rijksmuseum Kröller-Müller

10. *The Smiling Spider*. 1881. Charcoal, 49.5 × 39.1 cm. (19½ × 15⅜ in.) Paris, Louvre (Cabinet des Dessins)

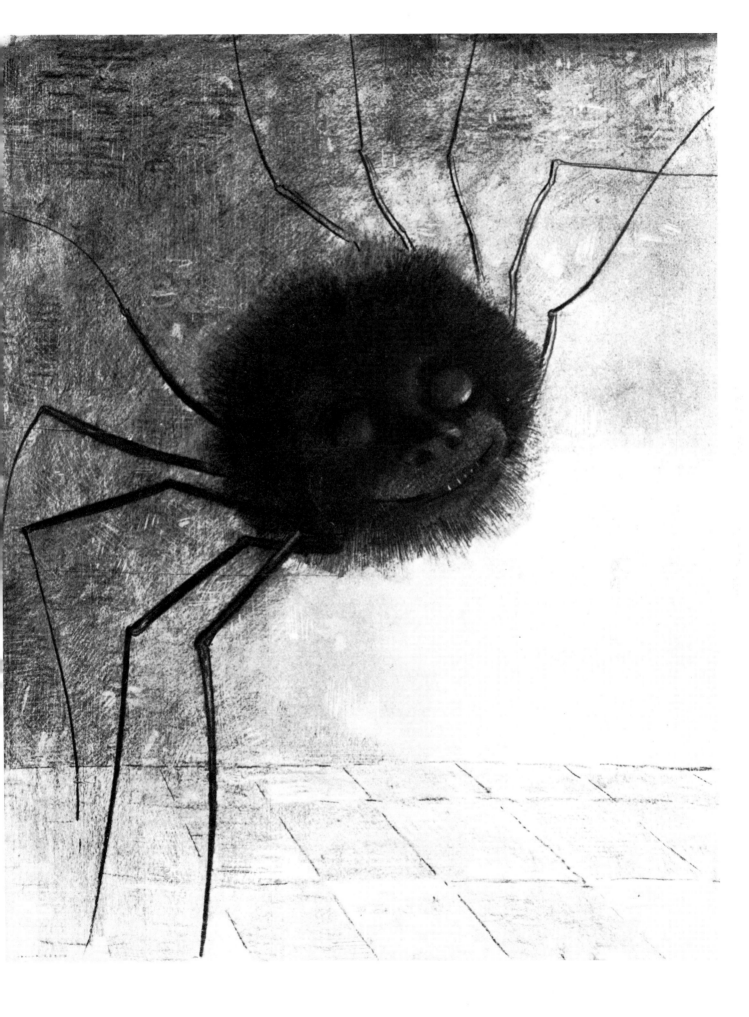

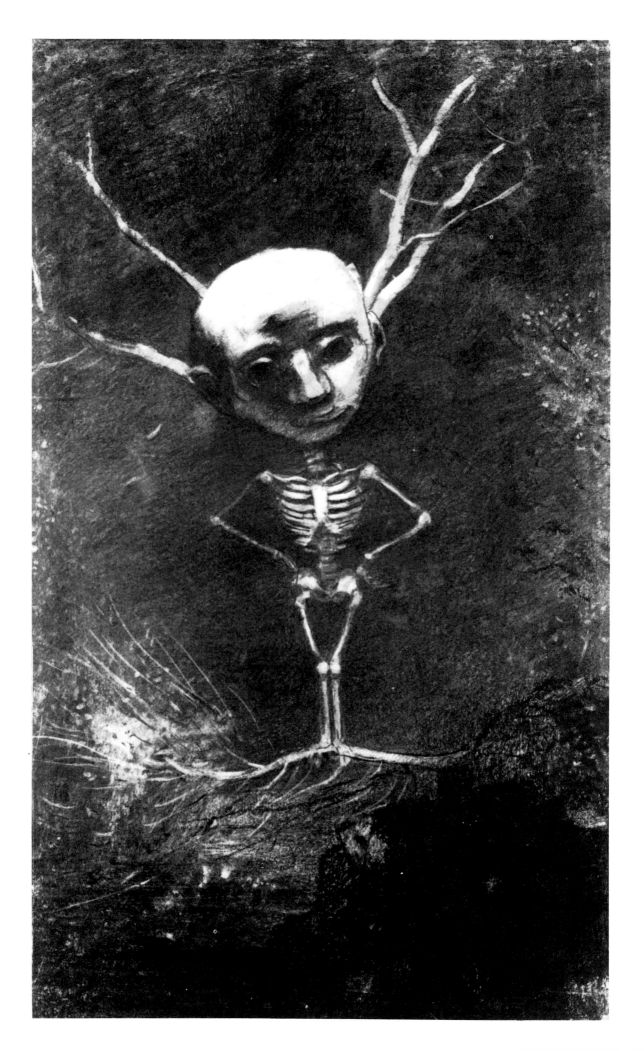

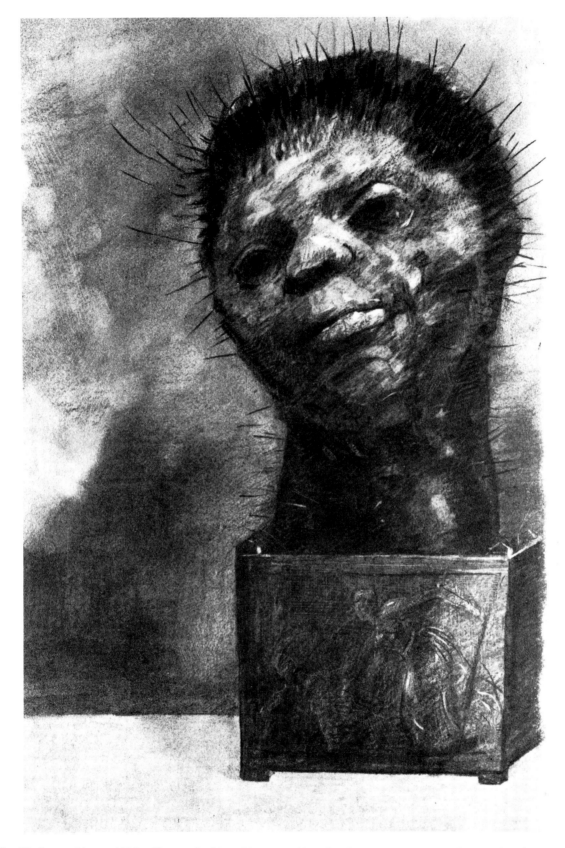

11. *The Skeleton*. About 1880. Charcoal, 45 × 28 cm. (17¾ × 11 in.) New York, Ian Woodner Family Collection

12. *The Cactus Man*. 1881. Charcoal, 46.4 × 32.4 cm. (18¼ × 12¾ in.) New York, Ian Woodner Family Collection

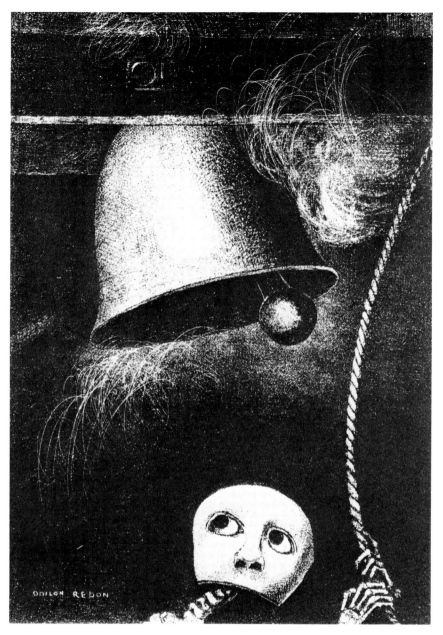

13. 'A mask tolls the funeral knell', *A Edgar Poe*. 1882. Lithograph, 15.9 × 19.4 cm. (6¼ × 7⅝ in.) London, British Museum

Between them these writers made the name of Redon familiar to supporters of the new literary movement, who yet had never seen or judged his work at first hand. He became known, not as a creator of highly personal fantasies, but as a new exponent of decadence and pessimism.

This sudden fame dictated the reception and orientation of the next lithographic series: *A Edgar Poe* of 1882, and *Les Origines* of 1883. Huysmans claimed that Redon was the heir of Goya, Baudelaire and Poe, and in dedicating the 1882 album to the American inventor of nightmarish fictions Redon was appealing to a popular cult. He later confessed that he felt little enthusiasm for the writer and had adopted the title merely as a means of attracting attention. He also for the first time

14. 'Next there appears a curious being having a man's head on a fish's body', *La Tentation de Saint Antoine*. 1888. Lithograph, 27.6 × 16.9 cm. (10⅞ × 6⅝ in.) London, British Museum

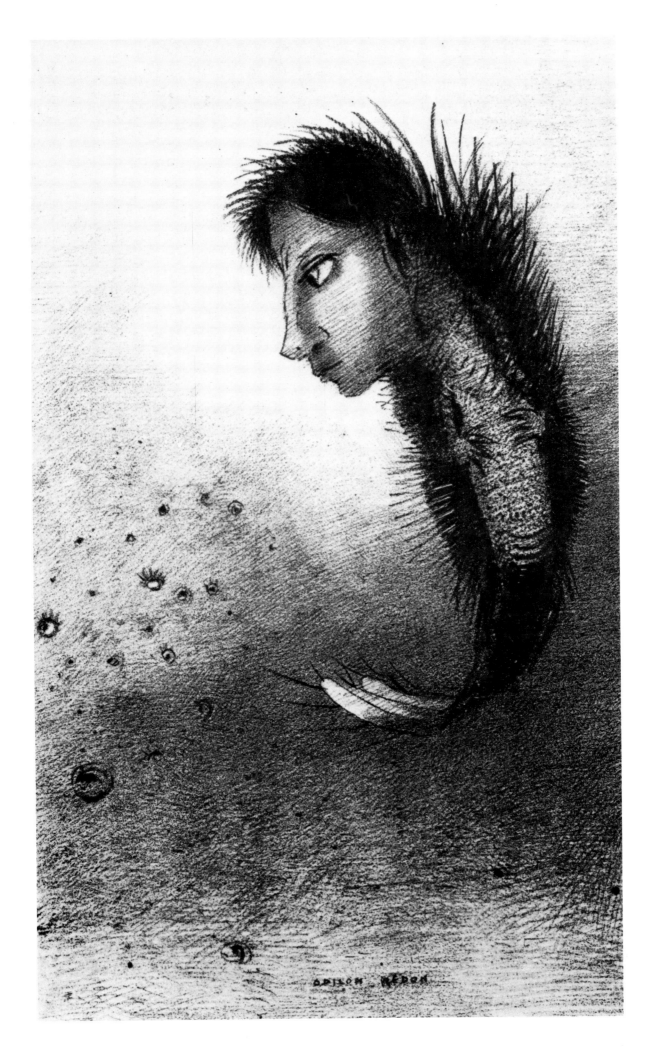

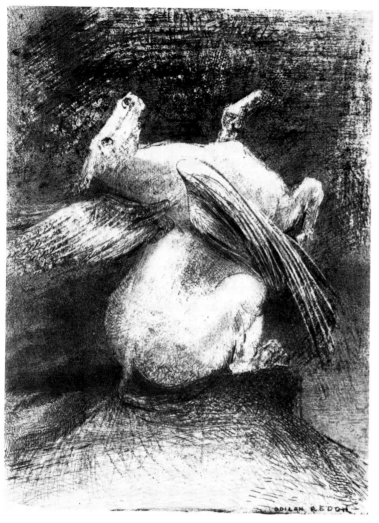

applied captions to the pictures, of his own invention, which confirmed for many the literary orientation of his work. *Les Origines*, which originally appeared without the captions that Redon had composed for it in a type of prose poem, was accepted, by Huysmans among others, as a commentary on the theory of evolution. In the plates of primitive life forms and such mythological creatures as the cyclops, the centaur, the satyr, and Pegasus (Fig. 15), critics saw the representation in poetic terms of life before man. Redon intended his art to be suggestive, open-ended, and yet his imagery—heads with wings, flowers, spiders and eggs with human faces, masks and skulls—belongs to the Romantic repertory and was therefore linked without question by writers of the Decadent School to the ideas which they wished to promulgate.

The alliance with writers in the 1880s thus proved for Redon a mixed blessing—an undoubted stimulus to his art and career, but a misrepresentation of his aims. In 1884 he exhibited with the newly founded Société des Artistes Indépendants, involving himself with its organization, and more lithographic albums began to appear: in 1885 *Hommage à Goya*, and in 1886 *La Nuit*, both of which bore prose poem commentaries of his own making. The blend of language with evocative images in these series appealed once more to his supporters and confirmed his reputation. He participated in 1886 in the last Impressionist exhibition and was invited in the same year to exhibit with Les XX, a Belgian group dedicated to Symbolist theories, established in 1883. The hostility his work aroused in the press is a measure of the name he had already made in Belgium. Admirers and detractors

15. 'The powerless wing did not raise the beast at all into those black spaces', *Les Origines*. 1883. Lithograph, 29.5 × 21.9 cm. (11⅝ × 8⅝ in.) London, British Museum

16. 'In my dream I saw in the sky a face of mystery', *Hommage à Goya*. 1885. Lithograph, 29.2 × 23.8 cm. (11½ × 9⅜ in.) London, British Museum

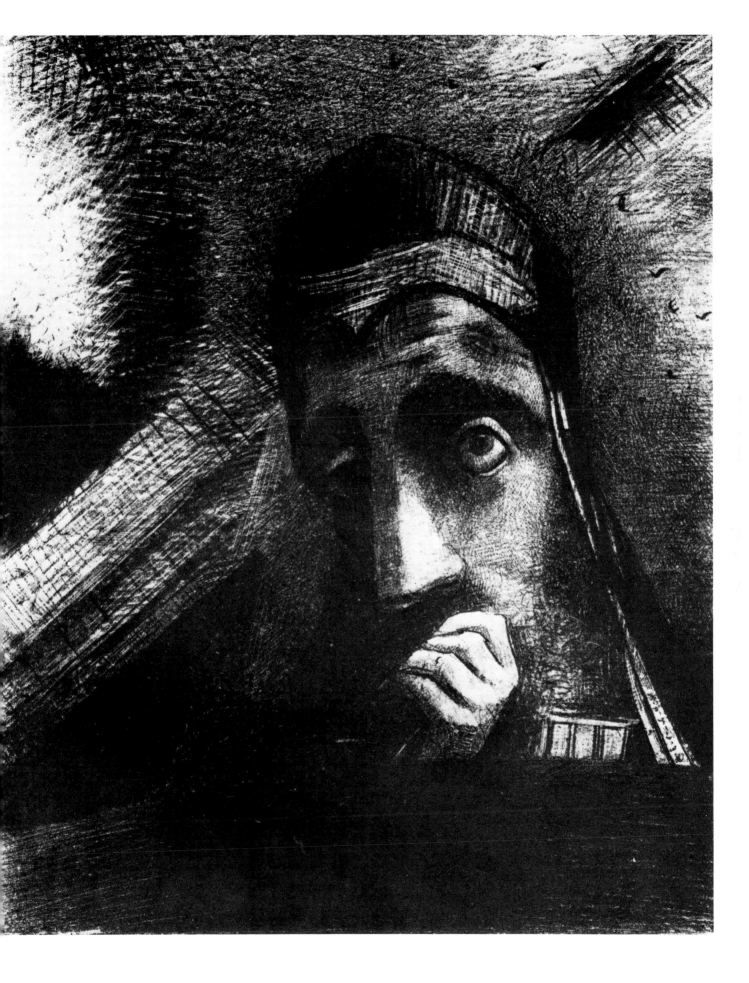

alike associated him with the hero of Huysmans's novel, and either, like the writer Jules Destrée, hailed him as the creator of macabre fantasies, or vilified him as an anarchist and a maniac. Yet the immediate consequences of his notoriety were fruitful. Edmond Picard, one of the prime instigators of Les XX, and an active lawyer, politician and patron of the arts, commissioned Redon to produce a series of lithographs to accompany his poetic monologue *Le Juré*, which was performed at the 1887 group exhibition. The theme of Picard's work is the guilt and suicidal despair experienced by a judge who is cursed by a condemned man, and while Redon had little sympathy with its function as social criticism, he was able to respond to the psychological elements, the torment and hallucinatory visions which the judge suffers. In accepting Picard's commission Redon reinforced his image as a literary artist and encouraged further propositions. He produced frontispieces to volumes by the Symbolist poets Emile Verhaeren and Iwan Gilkin, and in 1888 undertook with Edmond Deman, a Belgian publisher, to produce lithographs to Flaubert's *La Tentation de Saint Antoine*.

Flaubert's work was to provide Redon with a rich suggestive text and imagery for three lithographic series. When Hennequin presented him with the book in 1882, he did so recognizing the affinity to Redon's own art, but Redon's aims in treating literary texts, and his manner of doing so, remained largely unappreciated. How far he was independent of Decadent influence was obscured by his reticence and his amenability.

Until late in his career Redon was rarely acknowledged as an imaginative and innovatory graphic artist. He remained only a creator of monsters. In his essay of 1889, *Le Monstre*, Huysmans acclaimed him as the inventor of a new monstrous imagery, giving currency to the notion of Redon as master of the ugly. It is a conceptual approach, imposing a moral rather than an aesthetic interpretation upon visual form, and one to which Redon objected. It was a painter, Paul Gauguin, whom Redon had met through the Impressionist exhibition of 1886, who took up his defence, substituting 'imaginary beings' for monsters, and describing Redon as 'a dreamer, a man of imagination'. Redon was obliged to fight continually against his commentators, denying the intentions which they imputed to him. 'All the critical errors committed with respect to me on my first appearance', he later wrote, 'resulted from the failure to see that there is no need to define, understand or limit anything, to make anything precise, because all that is sincerely and genuinely new—like beauty, after all—carries its meaning within itself.' Writing to André Mellerio, his biographer, in 1898, he begs him to see in his lithographic works 'solely an artistic aim, even in the vague words which ornament them and are comparable to the musical directions on a sonata'. The captions to the series *A Edgar Poe* were added, he claimed, only to draw attention to the images, as a permissible trick, but one which cost him his innocence. Even the titles alone, he felt, had misled: 'The title is justified only when it is vague, indeterminate, and even tending to create confusion and ambiguity.'

He is in this at one with the Symbolist poets. Mallarmé, a friend and admirer of his work, speaking of the mystery of words, wrote, 'to name an object is to suppress three-quarters of the enjoyment to be found in a poem, which consists in the pleasure of discovering things little by little: suggestion, that is the dream.' Suggestive is the word Redon himself used to describe his art and the characteristic quality he admired in Rembrandt and Leonardo. Above all he sought vagueness, valuing it as the source of

mystery. 'My drawings inspire,' he wrote, 'and are not to be defined. They do not determine anything. Like music they take us into the ambiguous world of the indeterminate.' How much more true this is of Redon than of the artist critics insisted on coupling him with, Gustave Moreau. The extent to which the effect of Redon's images depend upon his technique can be amply demonstrated by comparing one of the most famous of his plates from *La Tentation de Saint Antoine* of 1888, showing a figure with a death's head (Fig. 19), with Moreau's *Chimera* (Fig. 18). The inventions are not unlike: a human torso is in each case fused with a coiling reptilian tail. But while Moreau's monster is depicted in traditional style with detailed naturalism within a landscape setting, Redon's is truly visionary, bearing no relation to everyday reality, and creating, in terms of black and white textures, a disturbing image of considerable resonance. In spite of his admiration for Moreau and his debt to him, he later made clear the disparity between them: the inner life remains in Moreau 'veiled beneath this essentially worldly art, in which the figures called to life are divested of their instinctive sincerity'.

In talking of his art Redon refuses adamantly to reveal the sources or significance of his images, insisting that the works be allowed to speak for themselves. He explains instead the processes by which they were made, in an effort to stress their visual and physical properties as against their much publicized content and meaning. Thus the assertion that his fantastic images are firmly rooted in observed reality: 'My whole originality consists in bringing to life in a human way improbable beings and making them live according to the laws of probability, by putting, as far as possible, the logic of the visible at the service of the invisible.' More helpful and more radical are his remarks

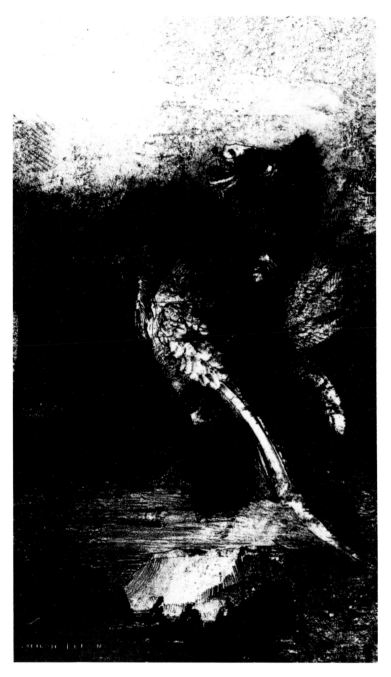

17. 'The green-eyed chimera turns, barks', *La Tentation de Saint Antoine*. 1888. Lithograph, 27.3 × 15.9 cm. (10¾ × 6¼ in.) London, British Museum

31

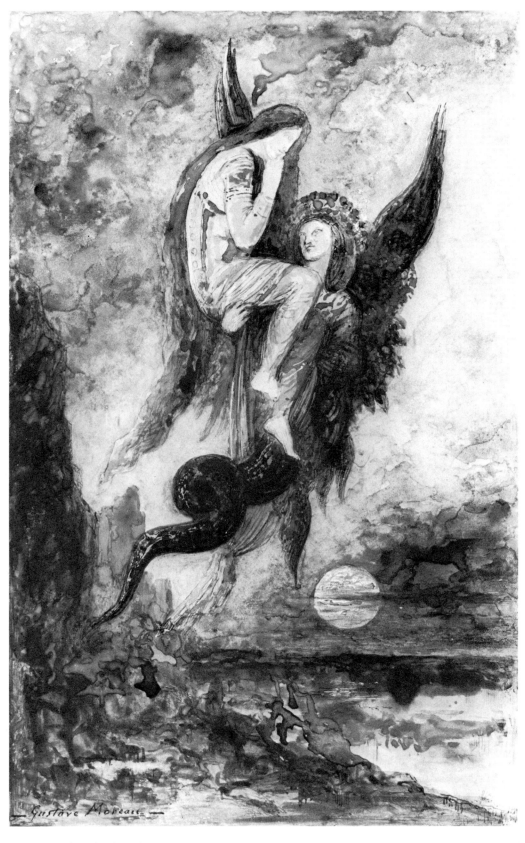

18. Gustave Moreau (1826–98): *Chimera*. Watercolour, 28.9 × 19.1 cm. (11⅜ × 7½ in.) Paris, Musée Gustave Moreau

19. 'It is a skull, with a wreath of roses. It dominates a woman's torso of pearly whiteness', *La Tentation de Saint Antoine*. 1888. Lithograph, 29.5 × 21.3 cm. B.M.

32

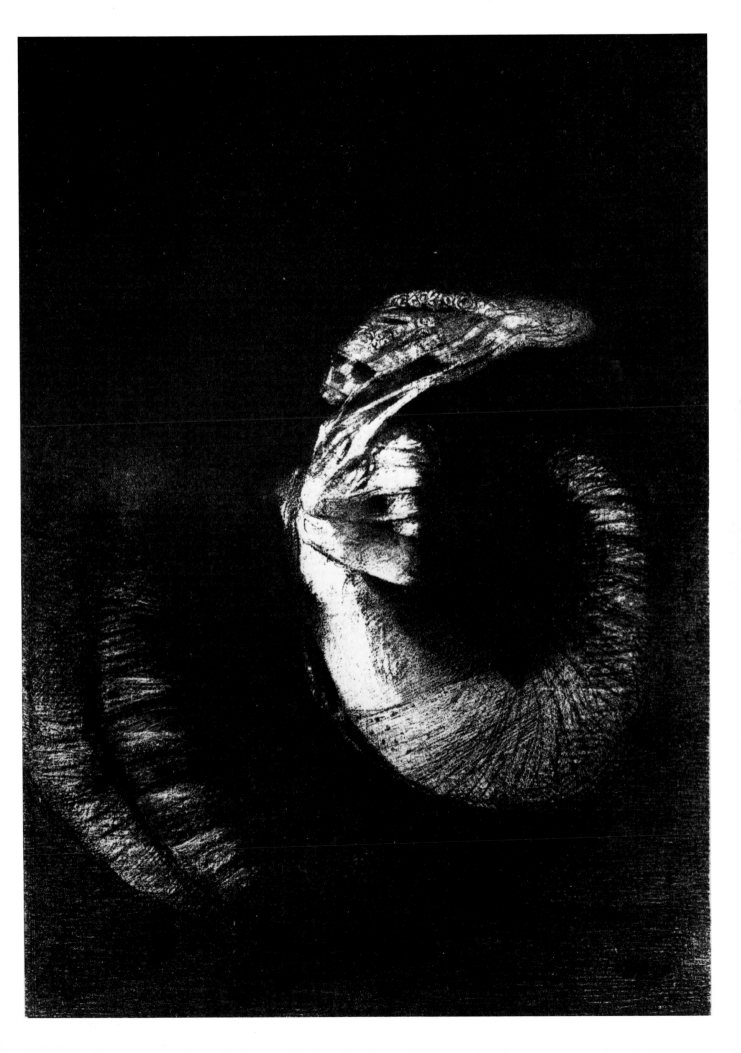

20. *The Resurrection of Lazarus.* About 1885. Charcoal with white highlights, 26 × 37.5 cm. (10¼ × 14¾ in.) Cambridge, Mass., Fogg Art Museum (Paul J. Sachs Collection)

about the importance of technique, how the nature of the medium governs and directs the imagination. He singles out that essential factor which distinguishes the visual artist from the writer or thinker when he says that 'a truly sensitive artist will not work out the same fantasy in different media, because they will exercise different influences on him.'

It is in their visual inventiveness and technical virtuosity above all that the power of the 'blacks', as Redon referred to his charcoal drawings and lithographs, resides. In the 1880s Redon's technique develops with confident assurance towards a complete

command of the abstract means of his art. Perspectival space disappears and is replaced by an ever increasing range of graphic devices. The reduction of images to geometrical shapes, like the circular face in the drawing *Marsh Flower* (Fig. 21), becomes more radical and, paradoxically, less mannered. In *The Resurrection of Lazarus* (Fig. 20), a drawing of the mid eighties, it is the dominant compositional motif and achieves a starkness and purity

21. *Marsh Flower.* 1885. Charcoal, 40.6 × 33 cm. (16 × 13 in.) The Art Institute of Chicago

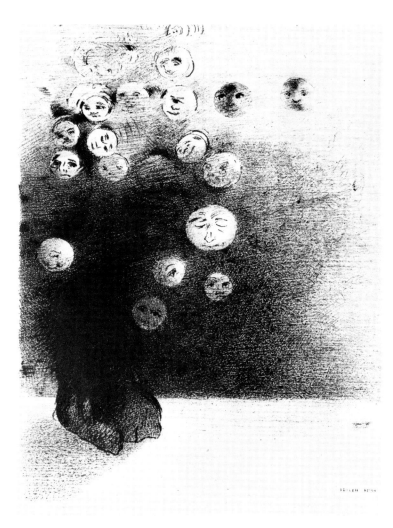

22. 'Must there not be an Invisible World?' *Le Juré.*
1887. Lithograph, 21.8 × 16.9 cm. (8½ × 6⅝ in.) London,
British Museum

rarely matched in Redon's work. Elsewhere, as in *Must there not be an Invisible World?* (Fig. 22), the play of shapes is augmented by subtle contrasts of tone.

It is a feature of the lithographs that an increasing use is made of textural and tonal effects as conventional drawing and space disappear. The density of the black in *Captive Pegasus* (Fig. 23), a lithograph of 1889, heightens the expressive charge. Some striking examples can already be found in the plates to *Le Juré* of 1887, in *The wall splits open and a death's head appears* (Fig. 25) and *The dream is consummated in death* (Fig. 26). The pearly diffused light in the latter recalls Millet's drawing technique and comes close to the tonal effects that Seurat was achieving at the same period in his own drawings (Fig. 24). It is evident again in the remarkable *Death: My irony surpasses all others* (Fig. 27) from *A Gustave Flaubert* of 1889, but what is most striking here in comparison with Redon's earlier efforts is the newly acquired linear freedom. All hardness has vanished and the image appears soaring in an indeterminate void. As in Van Gogh's pictures of cypresses, the decorative serpentine line of art nouveau is absorbed and transmuted into a totally personal idiom. Writing in 1898, 'in conscious maturity,' Redon insisted, 'all my art is limited solely to the resources of chiaroscuro, and it owes a great deal to the effects of abstract line, that power drawn from deep sources which acts directly upon our minds.'

In view of Redon's reticence and the indiscretions committed by his Symbolist commentators, it is perhaps foolhardy to pry further into the imagery of his work, and to seek the origins of his sinister creations. Yet some attempt is necessary if the transformation of the 1890s is to be understood; indeed Redon himself left pointers enough in the account he gave of his life: *Confidences d'Artiste*. As a man Redon remained un-

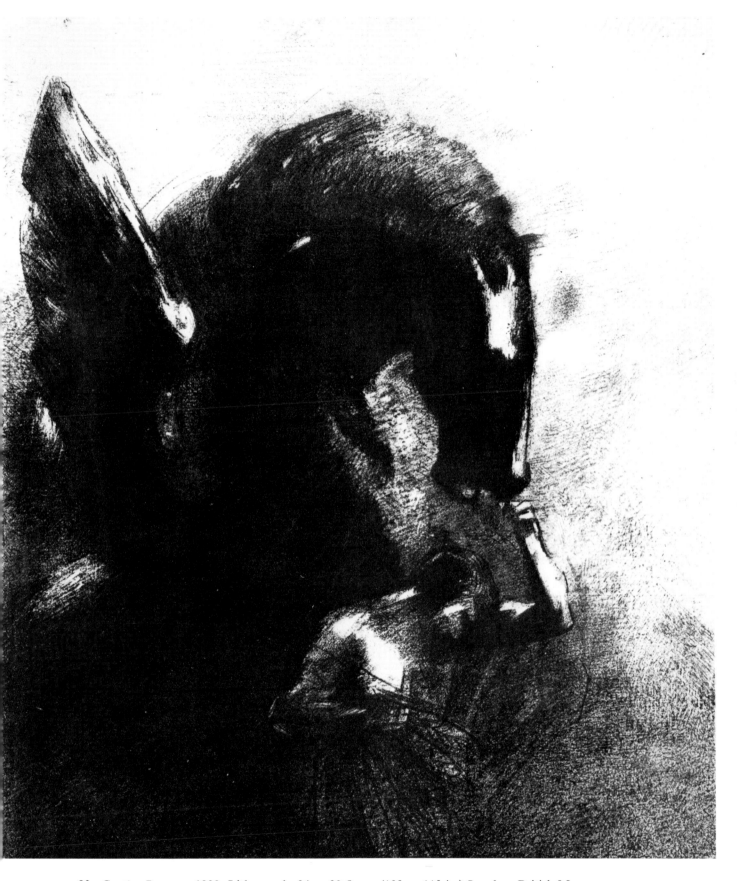

23. *Captive Pegasus*. 1889. Lithograph, 34 × 29.5 cm. (13$\frac{3}{8}$ × 11$\frac{5}{8}$ in.) London, British Museum

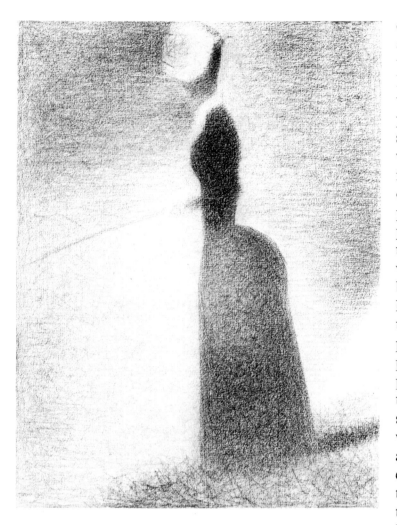

commonly retiring, and attached to the scenes and memories of his early life. Each summer until 1898 he returned to the family estate of Peyrelebade, where he had lived as a child, to work. Separated from his parents and placed in the care of an elderly uncle, he spent his early years alone, a sickly child with an aversion to physical activities and an inclination to dream. Evidently the experience of isolation on a decaying estate left its permanent mark on his imagination. He took pleasure in silence and shadows, hiding under trees and in corners of the mansion, around which extended a desolate heathland of brambles and pines. 'It was necessary there', he later wrote, 'to fill one's imagination with the unlikely, for into this exile one had to put something. After all it may be that in places most completely deprived of features pleasant to the eye, the spirit and the imagination must take their revenge.' It has been suggested that Redon's graphic repertoire, with its preponderance of images of darkness and death, is the manifestation of childhood experiences of anxiety and horror, of the traumas of an introverted child banished from the world. In 1913 Redon described his habitual mental state in youth as morose and melancholy. The premise of his 'blacks' could, he suggested, be found in a morbid preoccupation with death. If all this is the case, and such evidence as exists is very convincing, his graphic work is the medium by which he effected his own cure, rendering half-buried sensations in the tangible terms of an external art.

By expanding his technical range and proficiency Redon made possible an artistic expression no longer confined to the projection of melancholy or menacing visions, or dependent upon horrific imagery. Childhood spectres are replaced by a symphonic richness of visual devices. The discovery of colour in the 1890s confirms this liberation.

24. Georges Seurat (1859–91): *Woman Fishing*, study for *La Grande Jatte*. 1884–5. Conté crayon, 30.5 × 22.9 cm. (12 × 9 in.) New York, Metropolitan Museum of Art

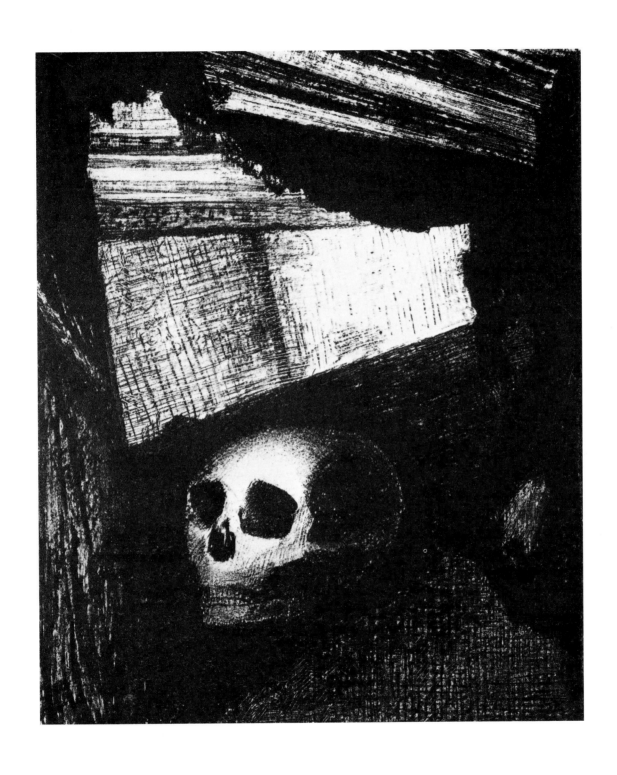

25. 'The wall splits open and a death's head appears', *Le Juré* (actual size). 1887. Lithograph, 17.8 × 15.2 cm. (7 × 6 in.) London, British Museum

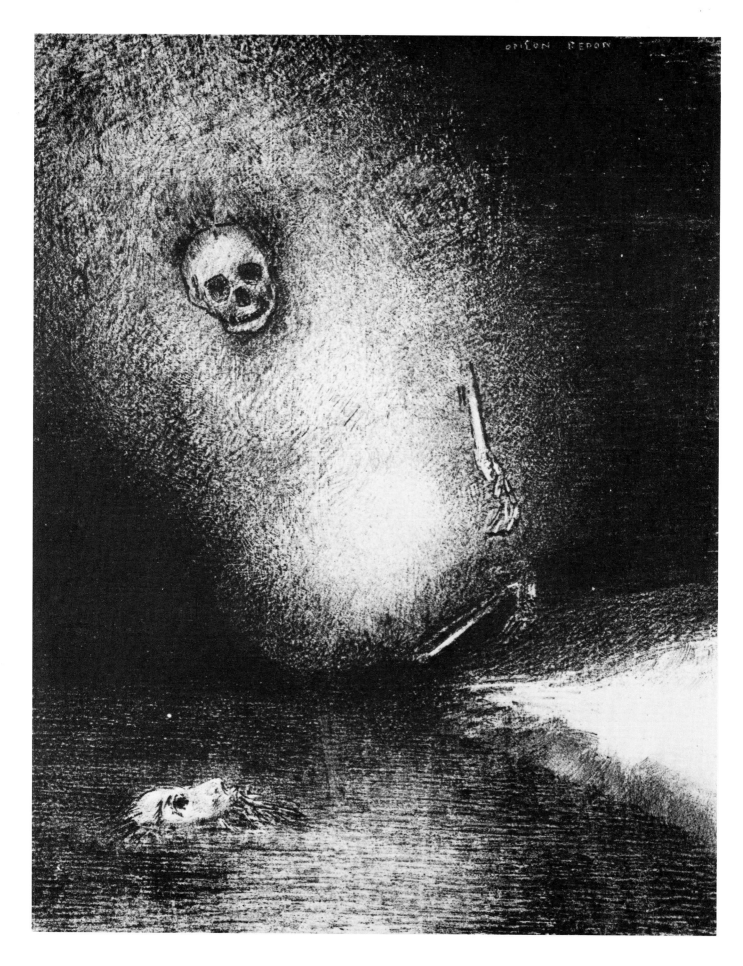

26. 'The dream is consummated in death', *Le Juré* (actual
size). 1887. Lithograph, 23.8 × 18.7 cm. (9¾ × 7⅜ in.)
London, British Museum

27. 'Death: My irony surpasses all others!' *A Gustave
Flaubert*. 1889. Lithograph, 26.7 × 19.7 cm. (10½ ×
7¾ in.) London, British Museum

Change

If Redon's critics had cared to look closely at his work they would have realized that his art never ceased to change. The 1890s stand out in this respect as years of particular significance. They represent a watershed in his career, at which he succeeded, not without enormous personal difficulty, in recasting the very form of his art, laying the foundations for the jubilant and heroic achievements of his last years. They saw the culmination of his lithographic oeuvre, in the four albums *Songes* (1891), *La Tentation de Saint Antoine* (1896), *La Maison Hantée* (1896) and *Apocalypse de Saint Jean* (1899), and the emergence of Redon as a master of colour.

Of all the circumstances that contributed to this change, the most significant was Redon's acquaintance with young artists. Not until his participation in the Salon des Indépendants and the Impressionist exhibition of 1886 had Redon been involved in any considerable way with painters. Contact with Gauguin and with Seurat brought an end to his isolation as an artist.

The 1880s had witnessed a reaction to Impressionism which left few untouched: Renoir renounced his technique of blurred form and blended colour in favour of a chastened linear style, and Pissarro adopted the system of divisionism which Seurat and Signac had developed. Dissatisfaction with the imitation of nature as an end in itself led artists to seek new ways of breaking out of the stranglehold of Realism, to create an art which by utilizing again the formal elements of painting—line and structure—would give expression to a more comprehensive vision, a synthesis of the natural and the spiritual. In this search, art itself, of many periods and cultures, constituted a valuable stimulus: Seurat looked to Ingres, Cézanne to Poussin, Renoir to Raphael, and Gauguin to primitive Cambodian art. Tradition became for them, as it had always been for Redon, an indispensable factor in the formation of their own styles. And Redon himself, as an artist who had eschewed naturalism in favour of independent structure and drawing, offered an example to them. Quite suddenly, with the change of artistic climate, Redon was recognized by fellow artists as a precursor of the new art, and a leader. In the 1890s, after Gauguin had departed for Tahiti, it was Redon who became to the Nabis—a group dedicated to the ideas of a spiritual and synthetic art and including Maurice Denis, Paul Sérusier, Bonnard and Vuillard—mentor and champion of their cause. The nature of Redon's presence, at once commanding and retiring, can be deduced from Maurice Denis's picture, *Homage to Cézanne* of 1900 (Fig. 29). The Nabis group and their dealer Vollard stand gathered round a Cézanne still-life—a symbol perhaps of artistic achievement—but the unnamed object of their veneration is the figure of Redon, who stands alone at the left of the picture. 'The lesson of Redon', Denis wrote, 'is his powerlessness to paint anything which is not representative of a state of soul, which does not express some depth of emotion, which does not translate an interior vision.'

Redon too benefited from his new friends. Recognition by painters gave him optimism for the future. Intimacy with their work and the example above all of Gauguin revealed to him the possibilities of colour as an independent means of expression rather than a way of imitating external reality. Painting had formerly constituted for Redon little more than an exercise. Since the 1860s he had produced landscape studies, still-lifes and portraits showing variously the influence of Corot, Chintreuil and Fantin-Latour. Some, like the painting of cliffs (Fig. 28), resemble in their simple analysis of structure Corot's oil sketches; others, like *Seated Woman in the*

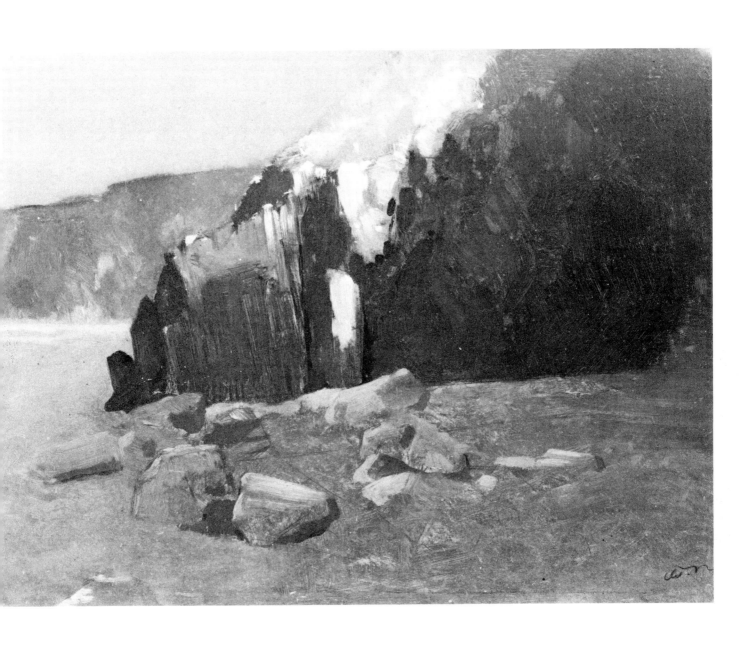

28. *Cliffs*. 1880 or 1883. Oil, 23.8 × 32.6 cm. (9¾ × 12¾ in.) Collection of Derek Hill

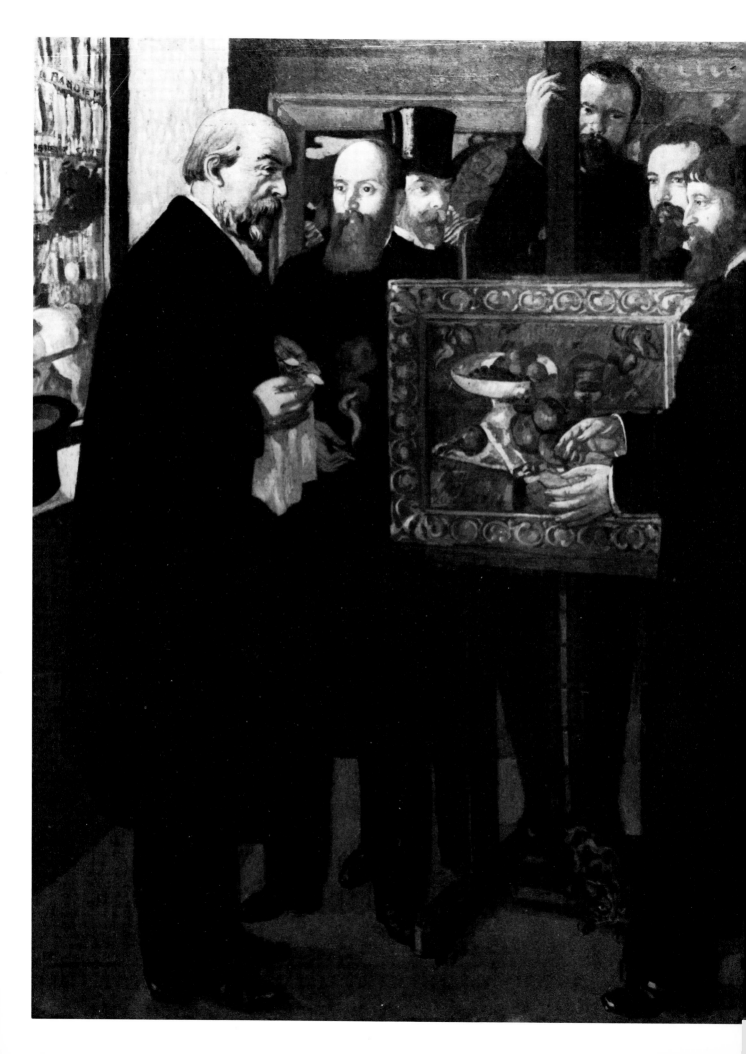

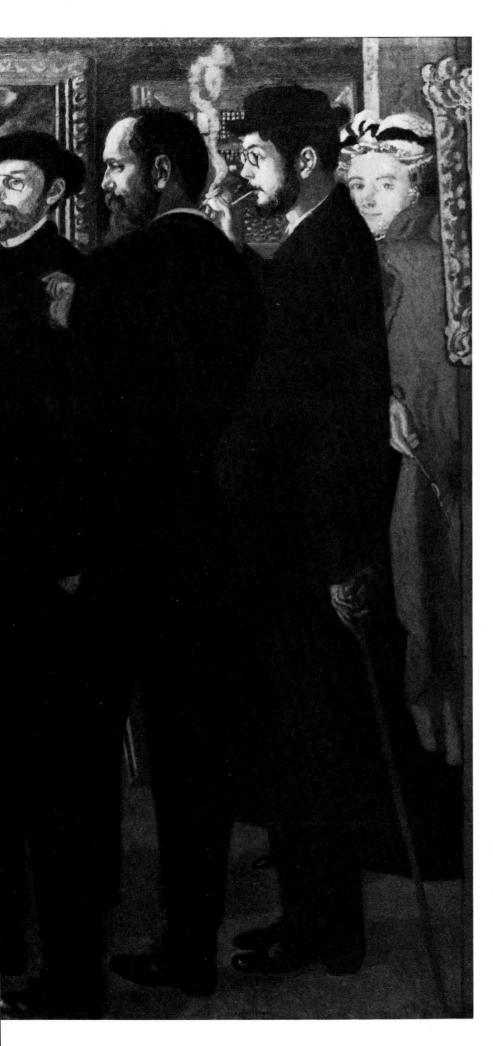

29. Maurice Denis (1870–
1943): *Homage to Cézanne*.
1900. Oil, 180.3 × 241.3 cm.
(71 × 95 in.) Paris, Musée
National d'Art Moderne

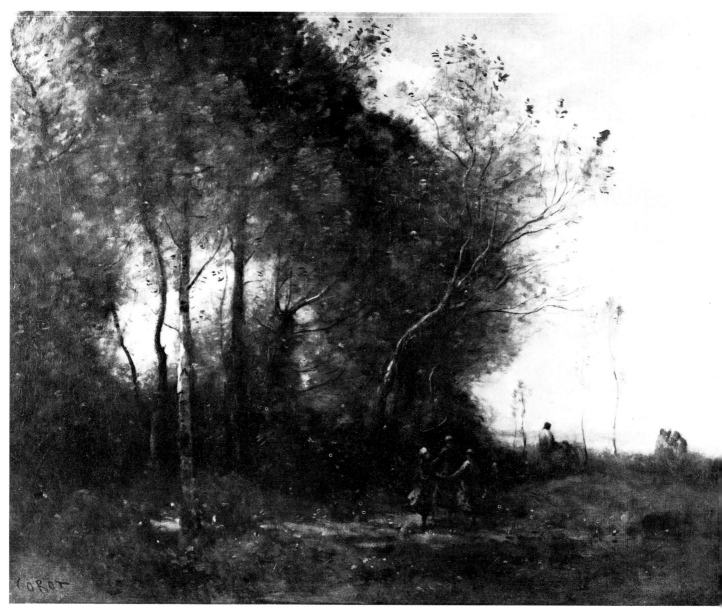

30. Jean-Baptiste-Camille Corot (1796–1875): *The Shepherds' Dance, Recollection of Arleux.* 1871. Oil, 62.2 × 80 cm. (24½ × 31½ in.) Paris, Louvre

Forest (Fig. 31), come closer to Corot's late manner, which Redon so much admired. The softening of form, the lyrical atmosphere and vertical emphasis all seem to depend upon similar effects in such pictures as *The Shepherds' Dance* (Fig. 30). It was only much later however that Redon began, slowly, to incorporate colour in his own imaginative compositions. *Closed Eyes* (Fig. 32) of 1890 shows the first tentative steps, muted colour adding to the quiet assurance of the image.

Although these years brought new and fruitful contacts, they were far from easy for Redon. Emile Hennequin had drowned in July 1888 while in Redon's company, and the death of other friends, of Bresdin in 1885, Clavaud in 1890, Mallarmé in 1898 and Ernest Chausson in 1899 abruptly severed his links with the past. Relations with his

31. *Seated Woman in the Forest.* About 1875. Oil, 33 × 20 cm. (13 × 7⅞ in.) Paris, Private Collection

46

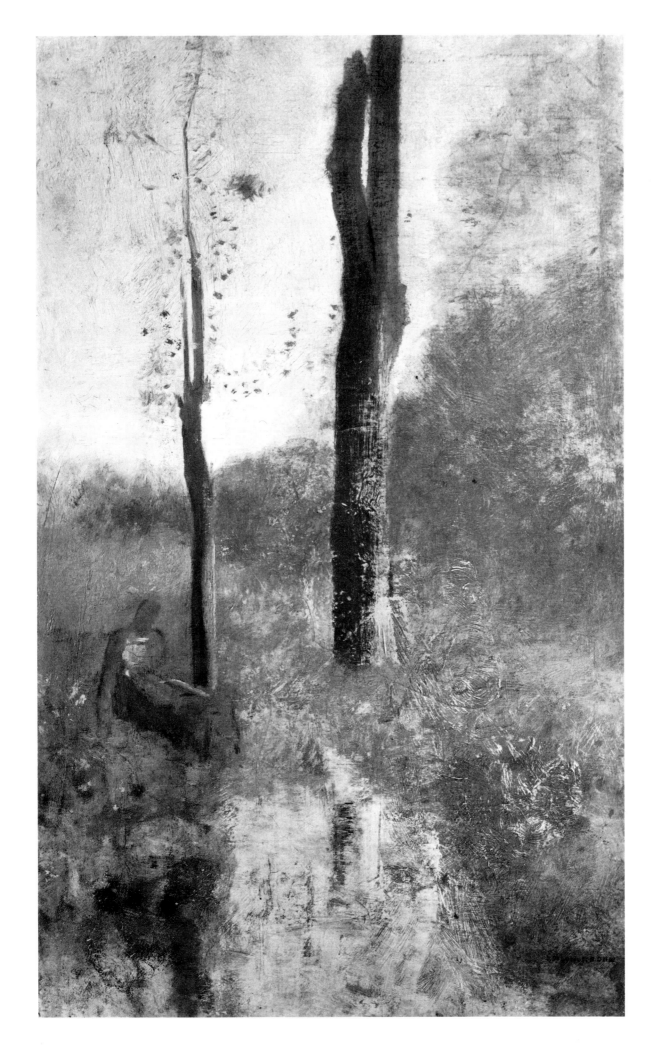

family contributed to his difficulties. Since the death of his father a dispute over the inheritance and the future of Peyrelebade had caused a bitter rupture with his mother and brother. His marriage sustained him in the midst of his troubles, but in 1886 the death of his first son in infancy caused him further distress. Like many of his Symbolist friends, Redon during the early nineties experienced a kind of religious crisis, the culmination of an involvement over a considerable number of years with mystical and spiritual ideas, and also perhaps the result of emotional stress. It is evident in the imagery of his work of the period, in the types of visionaries which appear in *Songes* and the lithographs based on Flaubert, and in the early colour work. The image of a face with closed eyes reappears time and time again, as a kind of metaphor for spiritual awareness. At times it is attached to a specifically religious subject, such as *The Sacred Heart* of 1895 (Fig. 33), but often, as in the painting *Closed Eyes* or the pastel *Golden Cell* (Fig. 34), the significance remains inexplicit and is left to be inferred from the image alone.

While there is much evidence for a heightened religious or mystical consciousness at this period, it is not limited in Redon's case to orthodox Christianity. Images of Buddha and obscure deities may appear alongside representations of Biblical subjects, like the *Flight into Egypt* (Fig. 35). This could be regarded merely as a reflection of current ideas, of Edouard Schuré's notion that art would provide a synthesis of all knowledge, religious and scientific. However it is also indicative of Redon's breadth and range of inquiry. Such friends as Maurice Denis, Emile Bernard, Paul Sérusier and his patron Gabriel Frizeau followed the example of Huysmans and espoused Catholicism again. Redon did not. A severe illness during the winter of 1894/5 marked the turning point for

him, the moment at which he proceeded to shake off the past of melancholy introspection and religious anxiety, and to develop an art unclouded by either.

Redon's refusal to identify himself with any particular sect or cult can be seen as an attempt to throw off yet another strait-jacket imposed on his art by admirers. Just as the Decadents had projected ideas of corruption, guilt and pessimism upon his work, so theorists of Symbolism, such as Charles Morice and Albert Aurier, imposed their notions of idealism, mysticism and synthesis. Redon was undoubtedly in sympathy with much idealist thinking of the time; some of his work is entirely consistent with the mystical ideas of the Rosicrucian group and its instigator Joséphin Péladan; but in their enthusiasm his admirers neglected the pictures. Critics were baffled by the colour works he showed at the retrospective exhibition held in 1894 with the dealer Durand-Ruel, and sought meanings in his choice of colour. Emile Bernard, a friend of Redon and a tireless advocate of his art, represented him as a type of visionary philosopher. 'People credit me with too much analytical spirit,' Redon wrote in 1888 and his attitude to theorists is clearly apparent in such remarks as: 'Metaphysical minds occupy themselves too much with abstractions to be able to share and taste to the full the pleasures of art, which always supposes an interchange between the soul and real external objects,' and, 'Art owes nothing to philosophy.'

The death of those who had most influence on his early career, and his refusal to adopt the doctrinaire views of his Symbolist colleagues or follow their return to the Church, left Redon at the end of the century in a state of reaffirmed independence. But not isolation. He retained a fruitful association

32. *Closed Eyes*. 1890. Oil, 38.1 × 30.2 cm. (15 × 11$\frac{7}{8}$ in.) Paris, Louvre (Jeu de Paume)

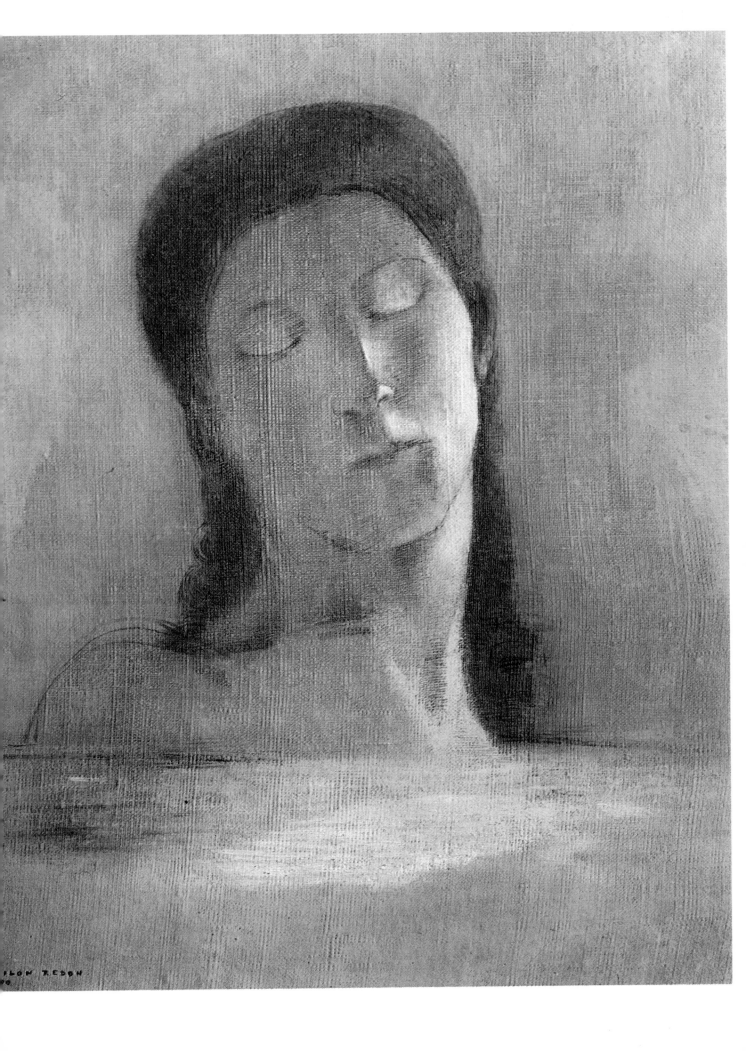

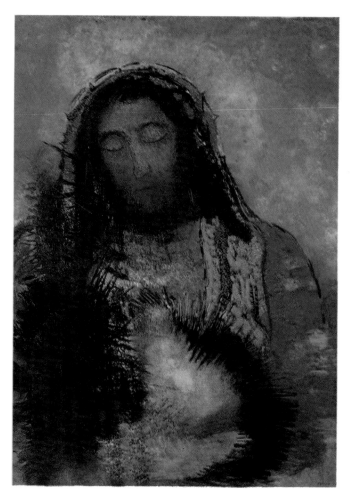

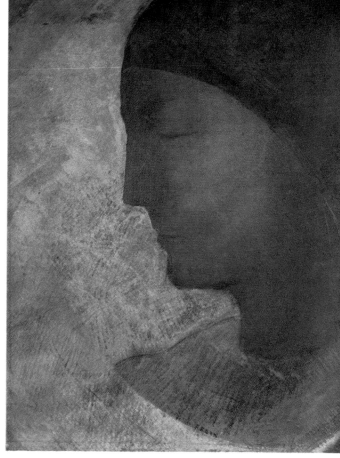

33. *The Sacred Heart.* About 1895. Pastel, 60 × 45.1 cm. (23⅝ × 17¾ in.) Paris, Louvre (Cabinet des Dessins)

34. *Golden Cell* or *Blue Profile.* About 1893. Pastel, watercolour and gold, 29.8 × 24.4 cm. (11¾ × 9⅝ in.) London, British Museum

with painters younger than himself and with a handful of dealers and collectors committed to his work. A new-found assurance is reflected too in the plates of *La Tentation de Saint Antoine* and *La Maison Hantée.* These last lithographic works demonstrate Redon's achievement of a painterly art. In illustrating Bulwer-Lytton's ghost story, *The Haunted and the Haunters,* Redon no longer has recourse to monstrous forms (Figs. 36, 37). Ordinary objects are invested with mystery merely by the agency of line, texture and tone.

The blacks and greys of these prints possess that immediate sensational appeal that is the property of colour, and anticipate the glorious colour effects of the late paintings

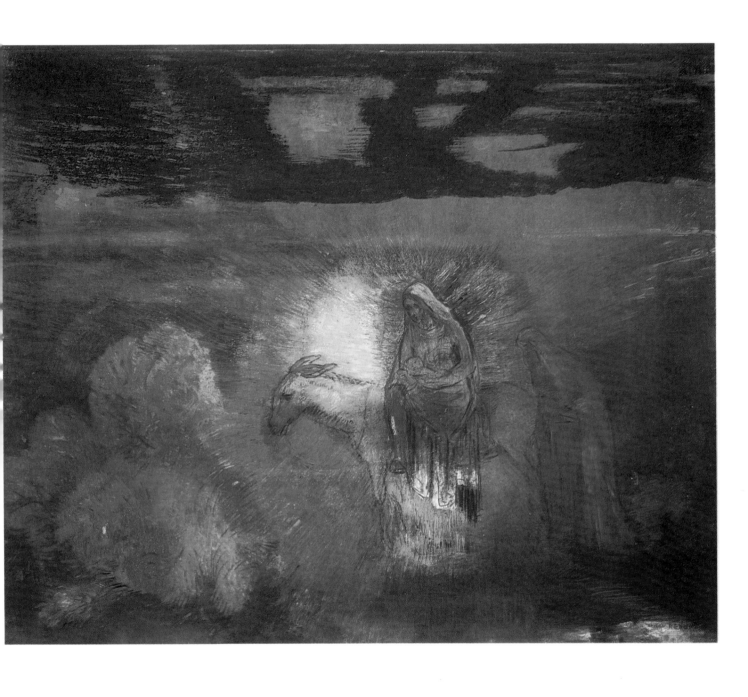

35. *The Flight into Egypt.* About 1902. Pastel and gouache, 50.2 × 61 cm. (19¾ × 24 in.) New York, Mrs John D. Rockefeller

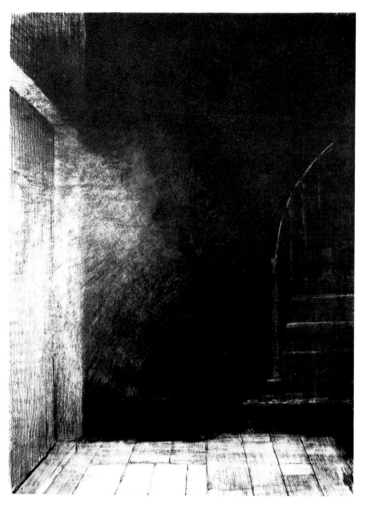

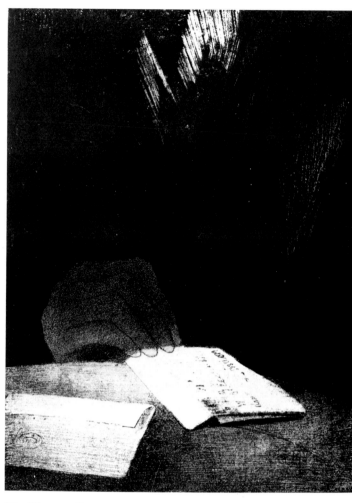

36. 'I saw a large pale light', *La Maison Hantée.* 1896. Lithograph, 22.9 × 17.1 cm. (9 × 6¾ in.) London, British Museum

37. 'From all appearance, it was a hand of flesh and blood like mine', *La Maison Hanté.* 1896. Lithograph, 24.4 × 17.8 cm. (9⅝ × 7 in.) Paris, Bibliothèque Nationale

and pastels. Seen in these terms they are the prologue to a new period of optimism, the Indian summer of Redon's art. His liberation would not have been complete, however, without one further event: the sale in 1897 of Peyrelebade, the family house. This finally severed Redon's links with the past and the memories and fears which had dominated his imagination since childhood. He confessed that it left him uprooted, but also relieved of a burden, and added with prophetic insight that it could not but have its repercussions on his art. The remarks of Redon's son, Arï, are

less oblique. He later said that the loss of Peyrelebade had been for his father 'a sort of deliverance: the rupture with the entire past of distress and anguish, the end of a nightmare, a bewitching spell. Now with liberty regained, the door was opened wide to life and to light. A new and beautiful existence began. After so many dark days it was the dawn of a long and happy period.'

38. 'Anthony: What is the object of all this? The Devil: There is no object!' *La Tentation de Saint Antoine.* 1896. Lithograph, 31.1 × 24.8 cm. (12¼ × 9¾ in.) Paris, Bibliothèque Nationale

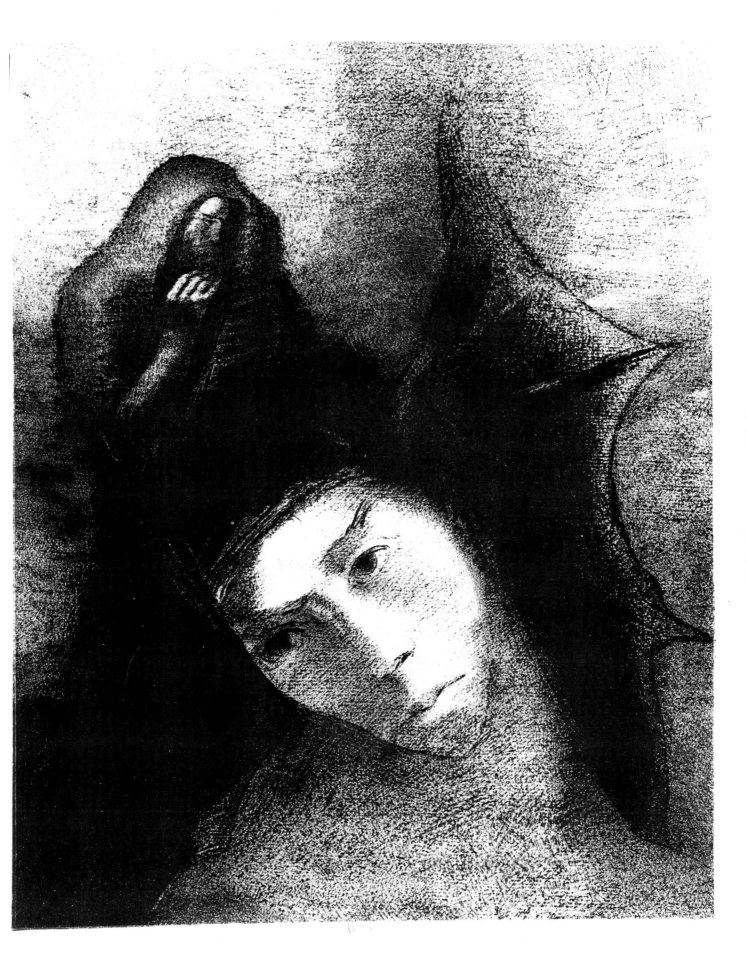

The Triumph of Colour

'Colours contain a joy which relaxes me; besides they sway me towards something different and new. Yet I could not speak to you of my projects—one doesn't know the art of tomorrow.' Redon had no idea in 1894, when he wrote these words to his friend Picard, of the role he yet had to play, of how after 1900 he was to enter a new triumphant phase as a colourist and be espoused by young artists for whom Symbolism bore little relevance, seeming outmoded and overburdened with ideas. Maurice Denis's painting, *Homage to Cézanne* (Fig. 29), already signals the recognition of Redon as a painter and of his kinship with other influential trends—such as that represented here by Cézanne's still-life.

The early years of the century saw the emergence of a new artistic climate. In their various ways Gauguin, Cézanne and art nouveau design contributed to a heightened awareness of the visual arts as decorative equivalents to sensational experience, rather than imitations of reality or vehicles for the expression of ideas. 'Never forget,' Maurice Denis wrote, 'that in its essence every painting is first of all a picture surface upon which colours are arranged in a particular pattern, and only then is it a war-horse, a nude or some anecdote.' For the first time in his life, when he was already past his sixtieth year, Redon ceased to be an outsider. He himself had helped to bring about this new approach to painting; now no longer alone he could benefit from the example of other artists sympathetic to his aims.

Redon's position as a leader of modern painting had been firmly established in 1899 when his work was included in a large Symbolist exhibition at Durand-Ruel's. After the turn of the century he continued to show regularly with Durand-Ruel and in 1901 exhibited for a second time with Vollard.

Official recognition came in 1903 when he was created a Chevalier de la Légion d'Honneur, and in 1904 the state purchased the painting *Closed Eyes* (Fig. 32) for the Luxembourg Museum. In the same year a whole room at the Salon d'Automne was dedicated to his work comprising over sixty exhibits, most of them in colour. Never had Redon enjoyed such exposure or publicity. Nevertheless he continued to be more popular with artists than with critics and his audience remained small. It included, however, a handful of men, *'mes amateurs'* as Redon called them, who not only, as collectors, offered financial support, but also in their loyal companionship proved their dedication to the artist and his aims. Andries Bonger, the brother-in-law of Theo Van Gogh, Gabriel Frizeau, a collector from Bordeaux, Arthur Fontaine and Gustave Fayet all contributed by means of generous commissions and the intimate friendship they shared with him to the achievements of Redon's last years.

The changed circumstances of Redon's life are reflected in the optimistic mood of his colour work. After 1900, tension and anxiety seem to disappear altogether; and the substitution of colour for black and white can be seen as an expression of this change. Redon himself interpreted the adoption of colour in these terms. 'In ceaselessly making myself more objective,' he wrote in 1913, 'I have since learned, with my eyes more fully open on all things, that the life that we unfold can also reveal joy. If the art of an artist is the song of his life, a grave or sad melody, I must have sounded the note of gaiety in colour.' Initially Redon worked chiefly in pastel, a medium which at the end of the century had enjoyed something of a revival. It enabled him to retain the graphic effects of his litho-

39. *Cyclops.* 1898–1900. Oil, 64.1 × 51.1 cm. (25¼ × 20⅛ in.) Otterlo, Rijksmuseum Kröller-Müller

54

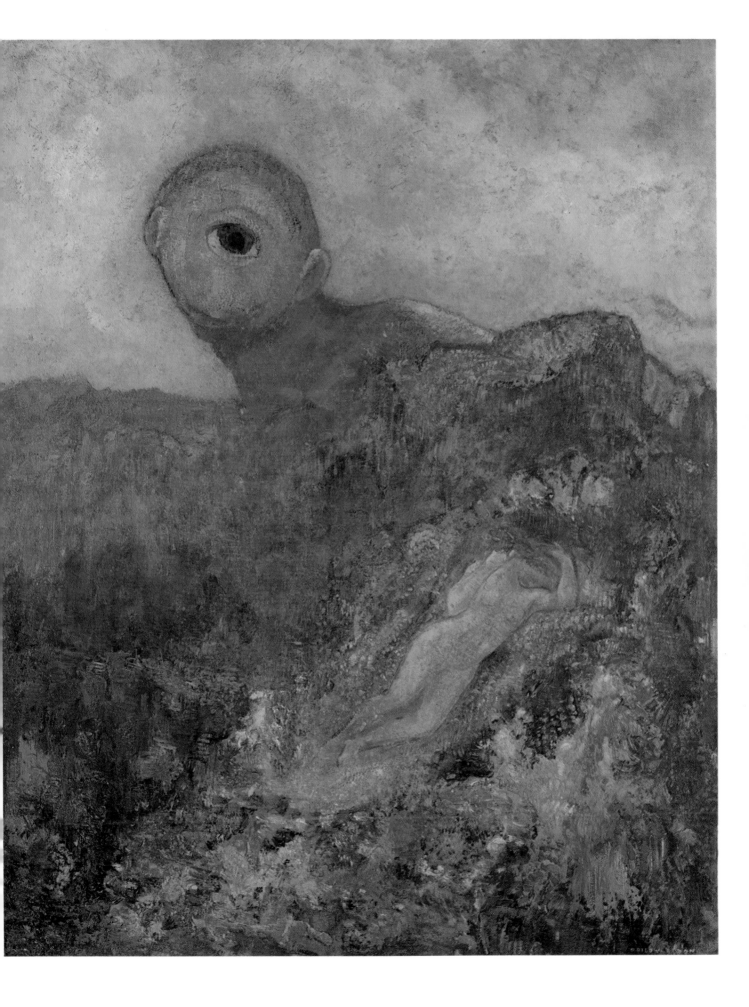

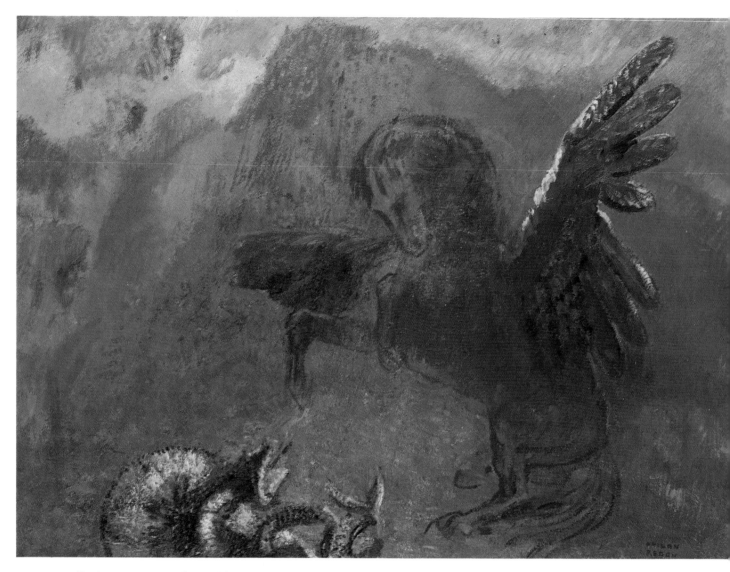

40. *Pegasus Triumphant*. About 1907. Oil, 47 × 62.9 cm. (18½ × 24¾ in.) Otterlo, Rijksmuseum Kröller-Müller

graphs while experimenting with rich, luminous colour. Oil paint permitted him to augment further the surface play of his designs with new textural effects derived from glazes and impastos. It is insufficient to see in Redon's development from monochromatic graphic work to fully-fledged oil-painting merely the gradual discovery of colour. The adoption of colour is only part of a slow and painful acceptance of the physical aspects of his art. Black had been the agent of his spirit. Only when the monstrous apparitions of the immaterial world began to recede was Redon able to make himself 'more objective', embrace colour, and utilize the more immediate and

more sensuous properties of paint.

And so it is no coincidence that the colour works after 1900 are optimistic and untroubled in mood. Pastel and paint come to represent a reconciliation with the external world. Flower-pieces and portraits, for example, play an increasingly important part in his work. Not that he ever became a naturalistic commentator on modern life; many of the old themes remain, but they no longer hold their former significance. Amongst the colour works are new interpretations of

41. *Orpheus*. About 1903. Pastel, 69.9 × 56.5 cm. (27½ × 22¼ in.) Cleveland Museum of Art (J. H. Wade)

56

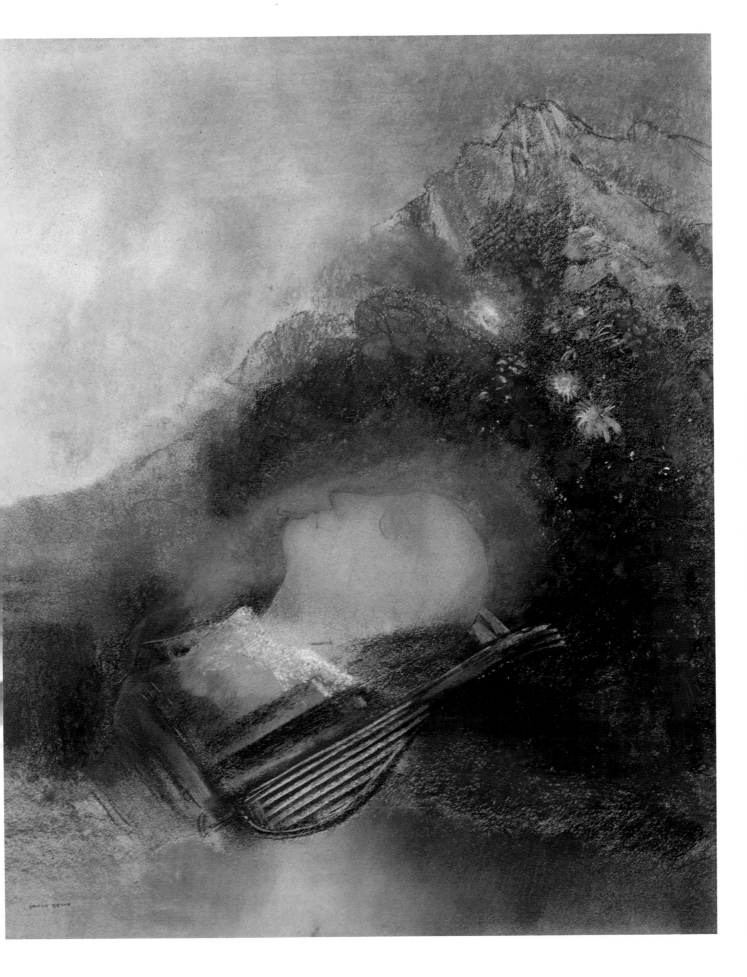

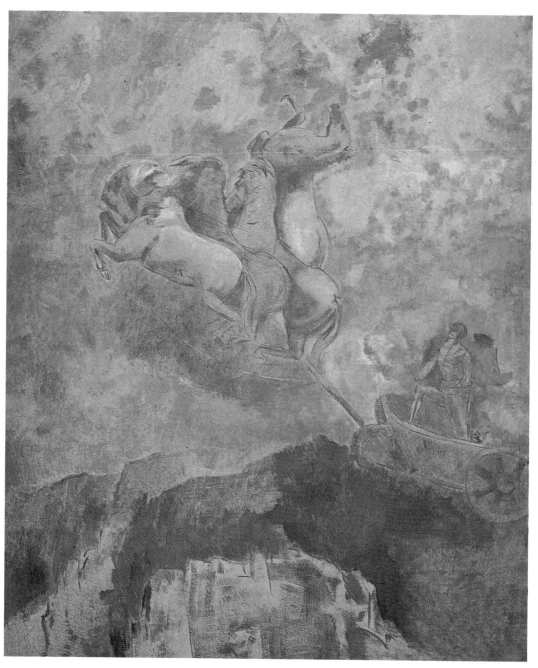

42. *The Sun Chariot of Apollo*. 1907–10. Oil, 100 × 80 cm. (39⅜ × 31½ in.) Bordeaux, Musée des Beaux-Arts

such mythological themes as the Cyclops (Fig. 39), Pegasus (Fig. 40), Orpheus (Fig. 41) and the Chariot of Apollo (Fig. 42); but Pegasus is now unchained and victorious, Orpheus appears as a disembodied seer in a magical world, and Apollo's chariot becomes, in colour, a symbol of the triumph of light over dark.

Such subjects may seem, in the first years of the twentieth century, old-fashioned and retrograde, but Redon himself regarded them as little more than pretexts for imaginative inventions. The figures of Roger and Angelica are almost lost in the fusion of intense colours

43. *Roger and Angelica*. About 1910. Pastel, 91.4 × 71.1 cm. (36 × 28 in.) New York, Museum of Modern Art (Lillie P. Bliss Collection)

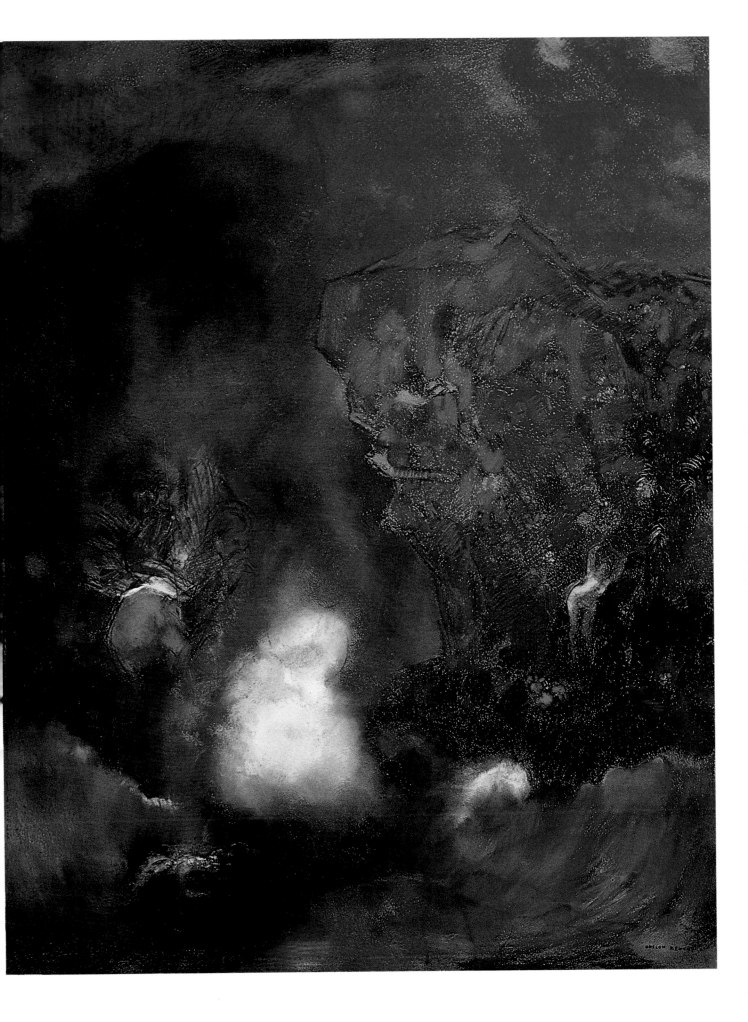

that constitutes this astonishing pastel (Fig. 43). The combat of hero and monster is evoked rather than described in the wild figurations and dramatic contrasts. The ex-

44. Eugène Delacroix (1798–1863): *The Triumph of Apollo*. 1849–51. Oil, Ceiling in the Galerie d'Apollon, Paris, Louvre

ample of Moreau, in whom Redon found a novel interpretation of mythology dependent on the artist's own sentiment, was precious to Redon, but not more so than that of Delacroix. Redon was well aware of the colour theories of Delacroix and Chintreuil, and in his treatment of the Chariot of Apollo and Roger and Angelica themes, he could not have ignored Delacroix's ceiling in the Galerie d'Apollon in the Louvre (Fig. 44). His remarks regarding this great painting are highly pertinent:

> This work, so powerful, so bold because it is novel, is altogether a poem, a symphony. The colour so undertakes to say everything and to give just expression, that the attribute which distinguishes each god becomes pointless. The rest of tradition, which he conserves still for clarity, is redundant.

It is a warning not to read too much into Redon's subjects. For example, pictures like *Buddha* (Fig. 45), *Oannes* (Fig. 46) and *The Red Sphinx* (Fig. 47) take up themes from the lithographs to Flaubert, but there is no good evidence to justify any limited religious or doctrinal interpretation of them. On the contrary, Redon objected to this type of analysis, and the general tenor of his work suggests rather a movement away from strict symbolism. Buddha, who seems to be associated by Redon with ideas of creativity, life and rebirth, does however have affinities with others of the colour works in which a figure, a type of visionary, seems to be in communion with the natural world, itself transformed through the perception of the seer or artist. *Orpheus* is one such work. The profile head and the closed eye, here as elsewhere, become synonymous with spiritual purity and artistic vision. These devices first make their

45. *Buddha*. About 1905. Pastel, 90 × 73 cm. (35$\frac{3}{8}$ × 28$\frac{3}{4}$ in.) Paris, Louvre

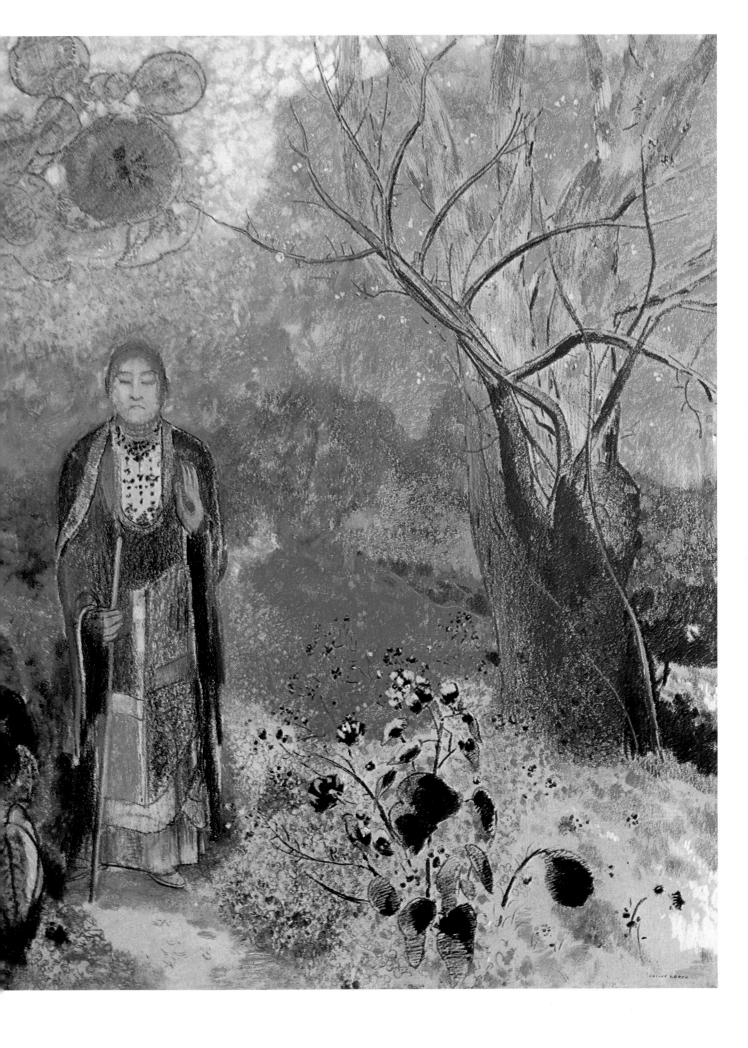

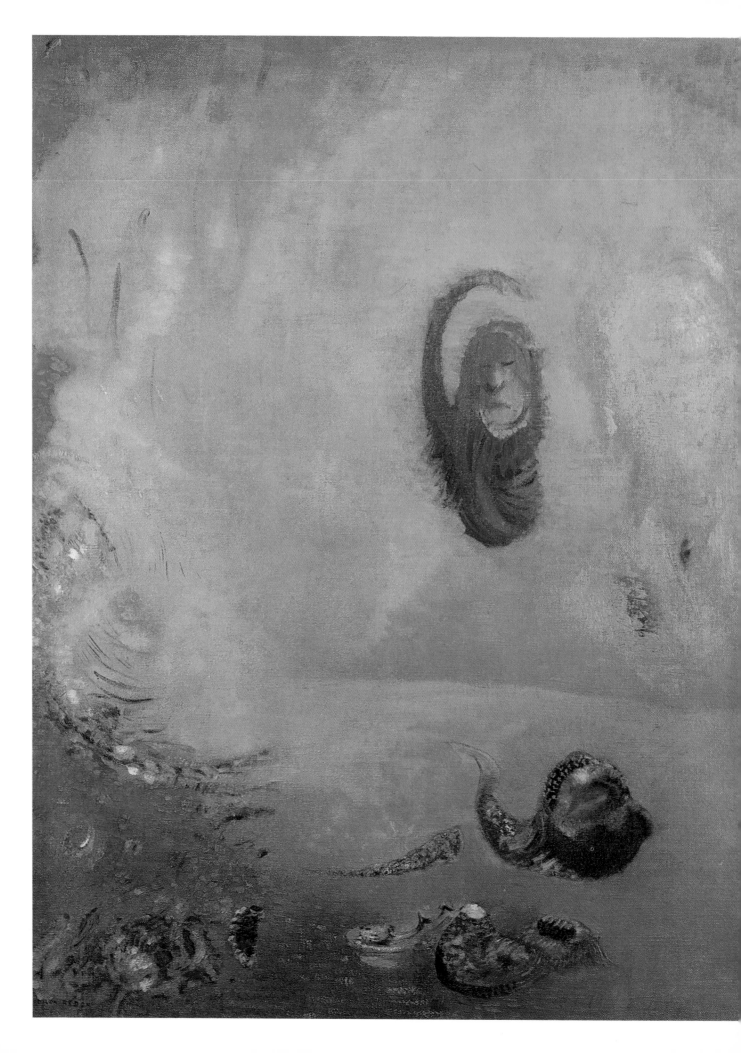

46. *Oannes*. About 1910. Oil, 64.1 × 48.9 cm. (25¼ ×
19¼ in.) Otterlo, Rijksmuseum Kröller-Müller

47. *Red Sphinx*. 1910–12. Oil, 61 × 49.8 cm. (24 ×
19⅝ in.) Switzerland, Private Collection

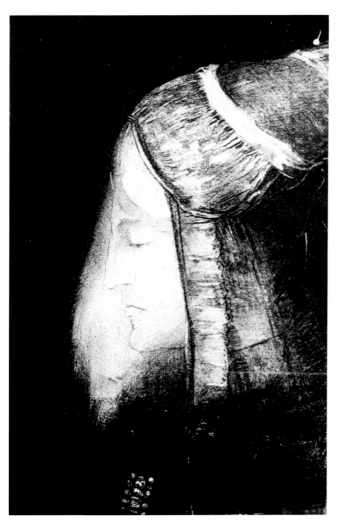

48. *Luminous Profile.* About 1886. Charcoal, 34.9 × 23.2 cm. (13¾ × 9⅛ in.) Paris, Musée du Petit Palais

49. *Brünnhilde, Twilight of the Gods.* 1894. Lithograph, 23.2 × 29.2 cm. (15 × 11½ in.) London, British Museum

appearance among the graphic works, in the charcoal drawing known as *Luminous Profile* (Fig. 48) for example, and again in the lithograph, *Brünnhilde* (Fig. 49), one of several showing the heroine of Wagner's *Ring*. What is most remarkable and significant in these particular works is the new guise in which Redon sees woman. No longer the *femme fatale* of the Decadents, nor the embodiment of death (Fig. 19), she has come to represent a calm and uncorrupted spiritual awareness. This concept may be unexceptional in the nineteenth century (there is more than a hint of the Pre-Raphaelite damozel in these ideal

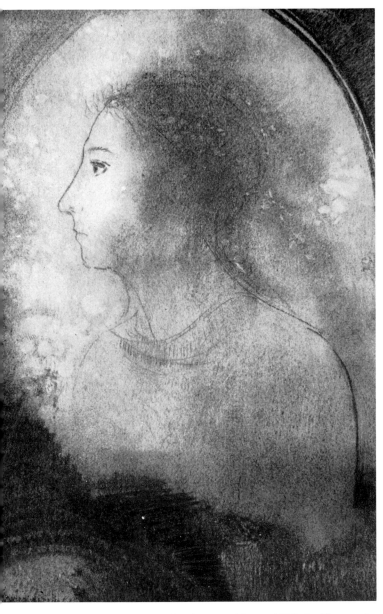

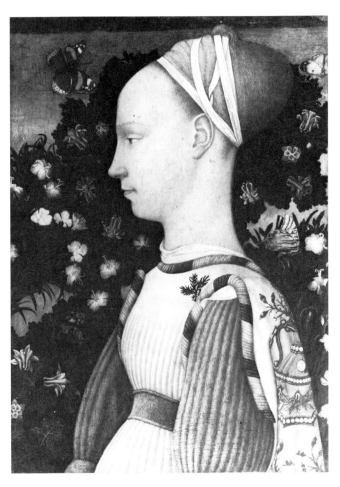

50. *Profile of a Woman with Flowers*. About 1890–5. Charcoal, 50 × 37 cm. (19¾ × 14⅝ in.) Otterlo, Rijksmuseum Kröller-Müller

51. Pisanello (living 1395 died 1455?): *Portrait of a Princess of the d'Este Family*. About 1441–3. Oil, 43.2 × 29.8 cm. (17 × 11¾ in.) Paris, Louvre

portraits), but the delicacy and economy of line in such a drawing as *Profile of a Woman with Flowers* (Fig. 50) brings with it artistic conviction. It is the treatment that lends the device of the profile resonance. In the *Golden Cell* (Fig. 34) it has already lost its gender and become universal.

The flat arabesque of the profile recalls Italian portraiture of the fifteenth century, and Pisanello's *Portrait of a Princess of the d'Este Family* (Fig. 51), which entered the Louvre in 1893, may have suggested to Redon the combination of an idealized profile with flowers that was to become for him a favourite

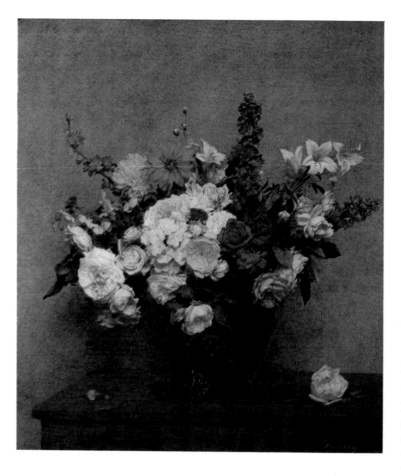

motif. Redon had since the 1860s painted studies of flowers; they formed the speciality of his friend Fantin-Latour (Fig. 52). Only, however, when Redon discovered the possibilities of non-realistic, imaginative colour, for which flowers offered a flexible and suggestive pretext, did they become central to his art. He created fantastic blooms of impossible brilliance and splendour, which are, as it were, the stuff of dreams, a vision of reality transformed. And so when they appear in conjunction with a figure or even a portrait, as in that of Violette Heymann (Fig. 54), they participate in a kind of dialogue.

It is this that distinguishes these pictures from those of Gauguin in which a pattern of flowers may, as in *La Belle Angèle* (Fig. 53), form a backdrop to the sitter, a flat decorative surround designed to concentrate meaning in the figure. There is no dialogue. Even when Redon's debt to Gauguin's cloisonné decorative effects is most evident, as in the painting, *Homage to Gauguin* (Fig. 56), the shapes of flowers still swim in the same ambiguous space as the sitter's head, rather than being fixed in an absolutely flat pattern. Redon's flowers constitute a magical environment that envelops the dreamer. His Ophelia (Fig. 55) is in her madness invested with the power of vision, so that the 'fantastic garlands' she bore to the brook where she drowned fill the picture to suggest a world of experience beyond everyday sensations. It is far removed from the type of Pre-Raphaelite illustration we find in Millais' famous treatment of the theme, and is the result in part of the action of the medium itself upon Redon. There

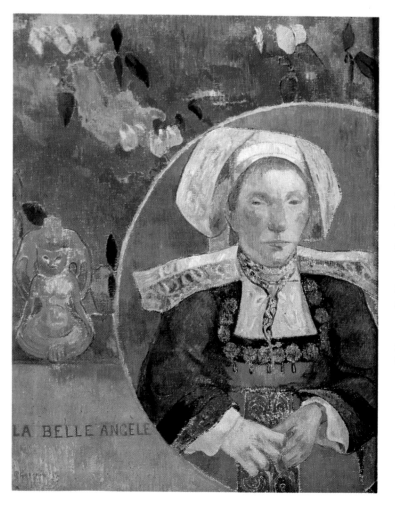

52. Henri Fantin-Latour (1836–1904): *The Rosy Wealth of June*. 1886. Oil, 70.5 × 61.6 cm. (27¾ × 24¼ in.) London, National Gallery

53. Paul Gauguin (1848–1903): *La Belle Angèle*. 1899. Oil, 92.1 × 73 cm. (36¼ × 28¾ in.) Paris, Louvre (Jeu de Paume)

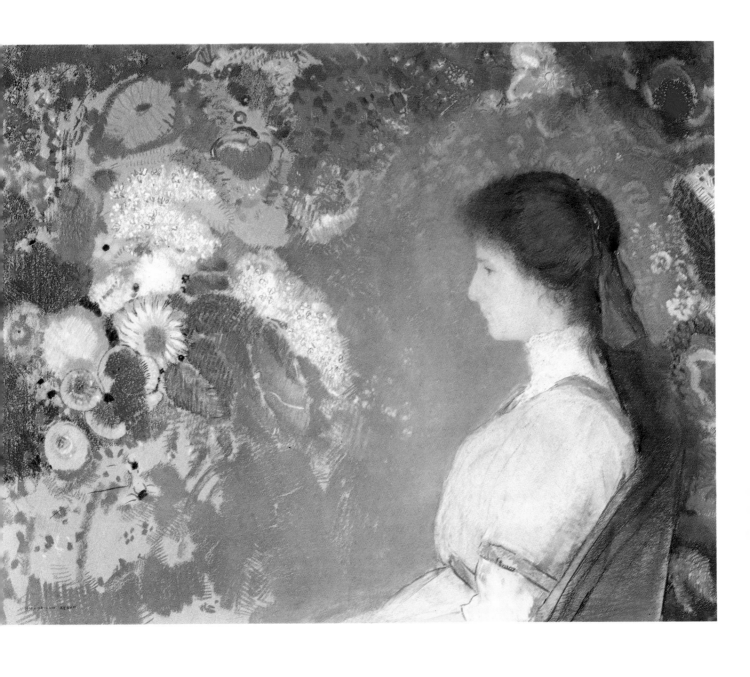

54. *Portrait of Violette Heymann.* 1909. Pastel, 72.1 × 92.4 cm. (28⅜ × 36 in⅜.) Cleveland Museum of Art
(Heinman B. Hurlbut Collection)

55. *Ophelia among the flowers.* 1905–8. Pastel, 64.1 × 91.1 cm. ($25\frac{1}{4}$ × $35\frac{7}{8}$ in.) London, National Gallery

remains in the blue and brown of the land-scape, if the picture is viewed on its side, the suggestion of a vase on a table-top. The composition as it now stands evolved from a pastel of a vase of flowers, into which Redon read further meanings, transforming it while he worked.

If Redon never accepted decorative effects as an end in themselves, he nevertheless benefited from the example of Gauguin. It was through his work and an acquaintance with the flat, asymmetrical design of Japanese prints that Redon learned that the vague projections of the imagination should derive their shape from the colour medium itself, be it

pastel, oil or watercolour. It is as a result of this lesson that all his late works do have a superb decorative quality and give an impression of being totally self-dependent. He began to produce in the new century decorative panels and screens in which the size strengthens the emotive effect of colour, screens like that he painted for his friend Bonger (Fig. 59), in which the Pegasus theme is the leaping off point for colour fantasies. In 1908 he was commissioned to produce cushion designs for the Gobelins factory, and

56. *Homage to Gauguin.* 1904. Oil, 66 × 55 cm. (26 × $21\frac{5}{8}$ in.) Paris, Louvre (Jeu de Paume)

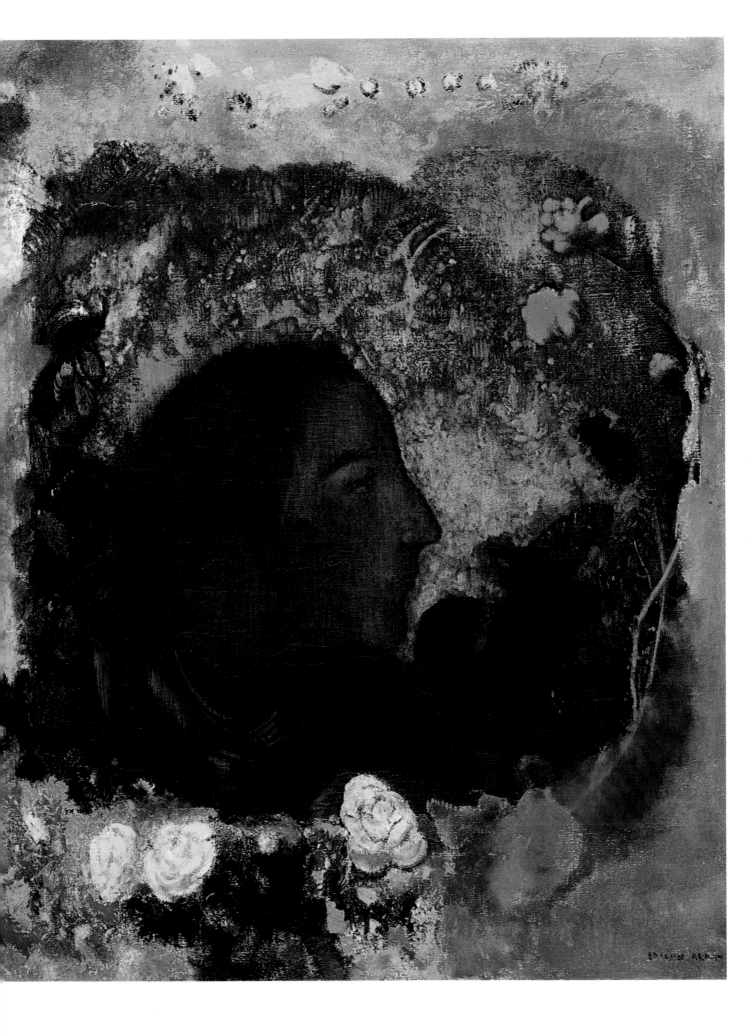

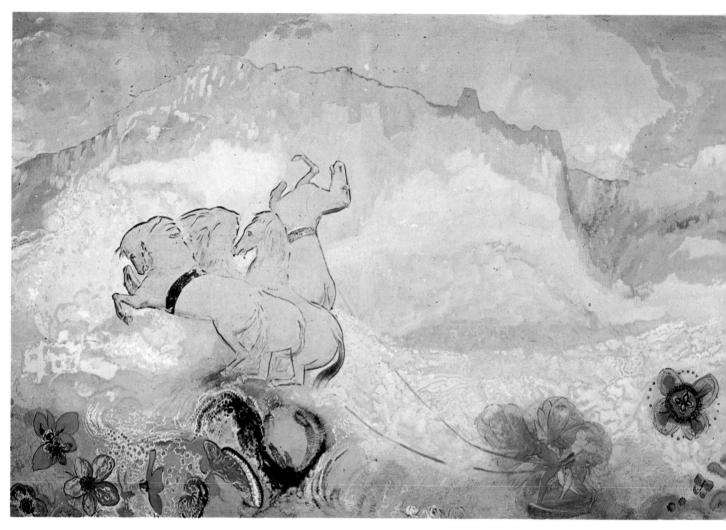

57. *Day*. 1910–11. Tempera, 198.1 × 650.2 cm. (78 × 256 in.) Narbonne, Library of Fontfroide Abbey

58. *Night*. 1910–11. Tempera, 198.1 × 650.2 cm. (78 × 256 in.) Narbonne, Library of Fontfroide Abbey

59. *The Red Screen*. 1906–8. Tempera, three panels, each 168 × 75.2 cm. (66⅛ × 29⅝ in.) Otterlo, Rijksmuseum Kröller-Müller

in the winter of 1910/11 he painted the largest of all his panels as decorations for the library at the former abbey of Fontfroide, the home of Gustave Fayet. The two main panels form a pair representing *Night* and *Day* (Figs. 57, 58) and borrow much of their imagery from Redon's earlier works. *Night* in particular shows Redon looking back to the mutant forms of his 'blacks'; odd winged creatures with faces hover in the air and lurk in shadows. But amongst them, strangely, are portraits of members of the Fayet family; there is an element of humour in his recollection of past horrors, and the mood is less menacing than teasing. *Day*, on the other hand, belongs with the expansive and affirmative colour works. Between trees and plants brimming with exotic details opens a wide vista with mountains, dominated by a quadriga driven by winged fairy creatures. Characteristic imagery is used alongside an apparently infinite abundance of pictorial devices, arabesques and patches of colour, having no meaning outside themselves, but combining to form a convincing and seemingly logical whole.

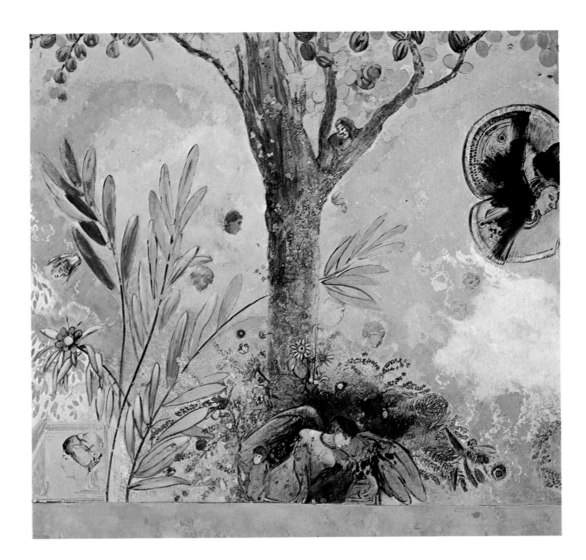

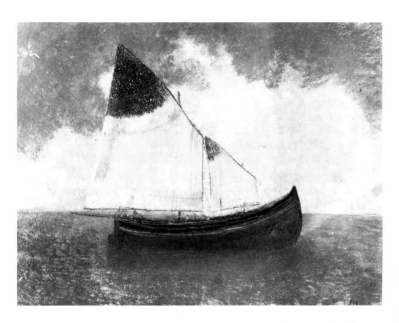

60. *Sailboat*. About 1905. Pastel. Private Collection

The Fontfroide decorations are perhaps in their very conception retrospective, a résumé in effect of Redon's career, for the development of his skill and range as a decorative colourist caused him elsewhere to depend less upon fantastic imagery and achieve an unfamiliar objectivity. He had recognized in the work of Bonnard 'a light and smiling' spirituality which arose purely from his gifts as a painter. At the beginning of the century he gained a new admirer in Henri Matisse and became friendly with another of the Fauves, Kees van Dongen. In their work he found a novel use of colour and line, combined with commonplace subjects, which perhaps convinced him that a suggestive art need not resort to unreal inventions. Painting depends above all, he wrote in 1903, on 'a gift of delicious sensuality, which can with a little of the most simple liquid substance reconstitute or amplify life, leave its imprint on a surface, from which will emerge a human presence, the supreme irradiation of the spirit'.

Just as he was able in his old age to welcome the sensuality of paint, so finally he no longer avoided the physical world of the senses. Mystery in his work henceforth arises out of matter, and not from its absence. The pictures of undersea life and of butterflies are free improvisations on natural themes. In *The Evocation of the Butterflies* (Fig. 62) the transformation of the subject into a symbol of natural perfection and ideal beauty is all the work of the colour medium. A boat at sea (Fig. 60) or a rider on the beach (Fig. 61) takes on mythical connotations while avoiding the fantastic, and conversely themes such as *Pandora* (Fig. 63) and *The Birth of Venus* (Fig. 64) are merely convenient pretexts for colourful compositions based on the female

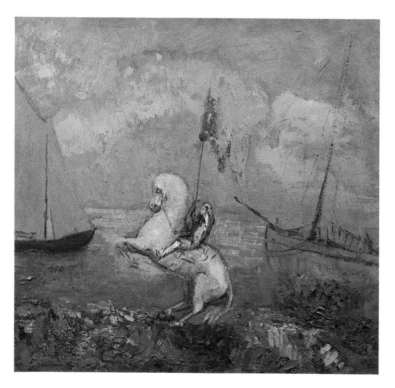

61. *Rider on the Beach with Two Ships*. 1905. Oil, 38.4 × 40 cm. (15⅛ × 15¾ in.) Bristol, City Art Gallery

62. *The Evocation of the Butterflies*. 1910–12. Oil, 55 × 41.5 cm. (21¾ × 16¼ in.) Detroit Institute of Arts

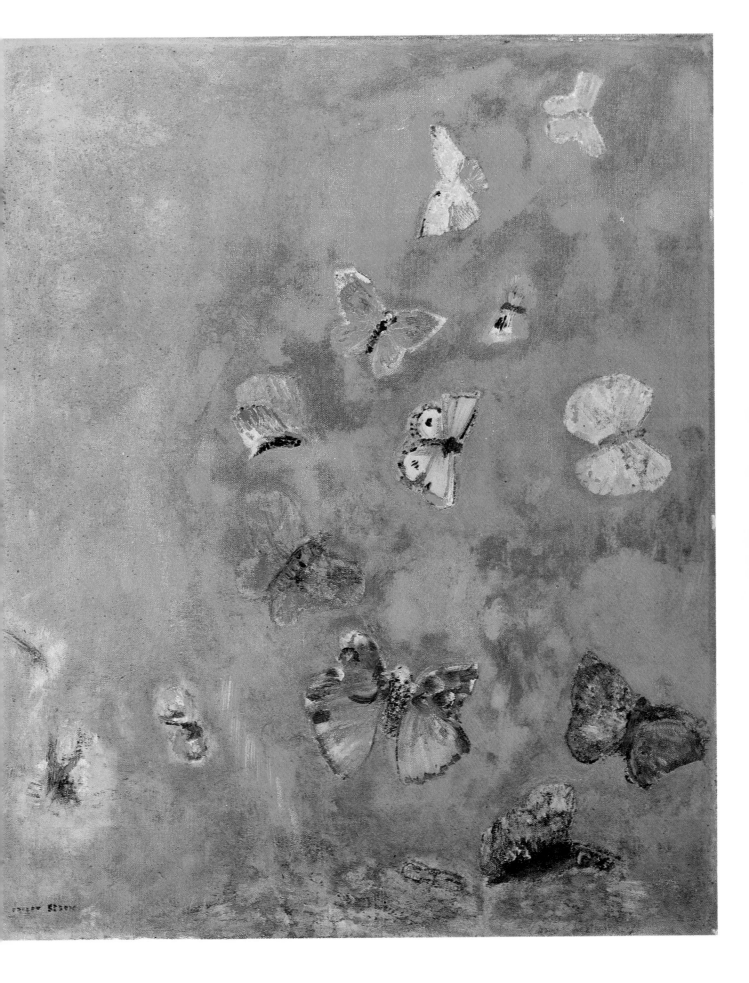

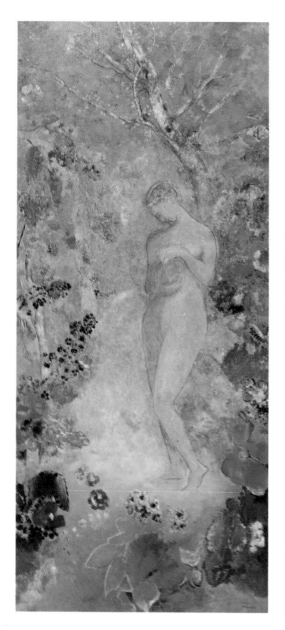

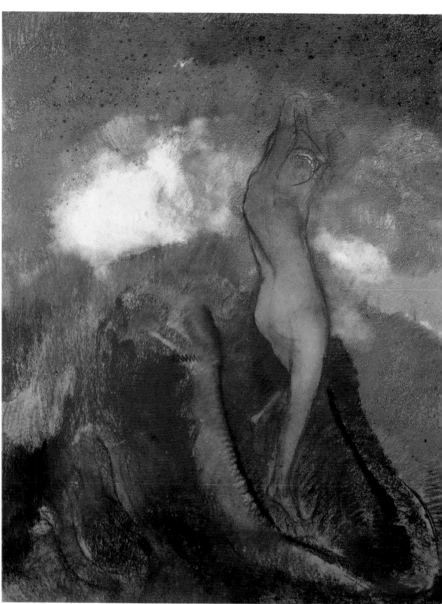

63. *Pandora*. About 1910. Oil, 143.5 × 62.2 cm. (56½ × 24½ in.) New York, Metropolitan Museum of Art (Bequest of Alexander M. Bing)

64. *The Birth of Venus*. About 1910. Pastel, 83 × 64 cm. (32⅝ × 25¼) Paris, Musée du Petit Palais

nude. In these the 'delicious sensuality' of the medium is at last equalled by the unabashed sensuality of the image. Form—be it the sinuous line of the contour or the mosaic of colour—matches content. It is remarkable that such uninhibited work should have flowed from Redon's brush in the last decade of his long life, but perhaps this youthfulness

too he owed to his easy relations with admiring young artists. Despite the idiosyncratic treatment of fine flower-like details, how much the pastel of a nude (Fig. 65) recalls the nudes of Matisse, in particular the simple fluent forms of *The Dance* (Fig. 66).

The late pastels and oils take as their premise some aspect of the objective world;

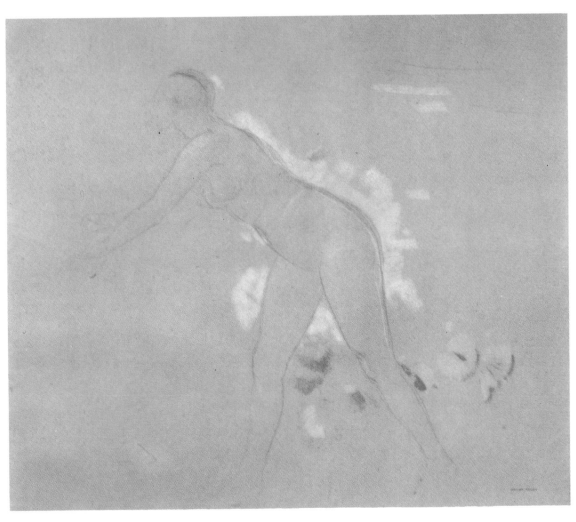

65. *Nude*. About 1911. Pastel and pencil, 60 × 67.9 cm. (23⅝ × 26¾ in.) Tokyo, Bridgestone Gallery

66. Henri Matisse (1869–1954): *The Dance*. 1909–10. Oil, 260.4 × 388.6 cm. (102½ × 153 in.) Moscow, Museum of Modern Western Art

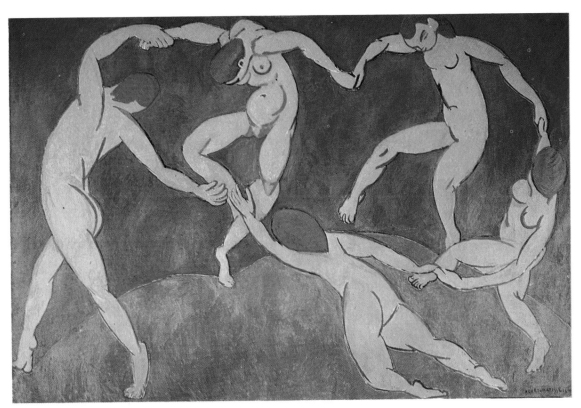

mystery and enchantment then arise from a decorative conception of colour and design. Nowhere is this more clear than in the flower-pieces. In those that date from before about 1910 Redon allows himself every liberty —inventing strange blooms, reducing flowers to flat shapes of colour, in fact eliminating spatial depth altogether, to create a pattern. By such means he evokes the physical beauty of flowers without attempting to portray it. In the little oil, *Flowers in a Green Vase* (Fig. 67), the jug and the flowers are flat decorative devices in a completely two-dimensional design. The emphatic Japanese-like asymmetry contributes to the abstract play of shapes. Redon's love of defined patches of colour enclosed by lines is yet more apparent in the large painting *Etruscan Vase* (Fig. 68), where he seems consciously to emulate Gauguin's 'primitive' decorative mode of composition, depending solely on two-dimensional movement and vigorous contrasts of shape and colour.

In order to reveal the beauty of these flowers, 'admirable prodigies of light', as he described them, Redon needs to render them less concrete. Fantasy is still with us. Only as he becomes more confident of his means, of the power of colour and pictorial construction, can he allow the flowers to reassert themselves as material objects of the physical world. But it is now clear that Redon goes much further than he has yet dared. In the last flower-pieces he abandons vague suggestion for crystalline form, evasive asymmetry for centralized design which confronts the subject head on, placing it in full view, the result of his own concentrated observation. The flowers in the pastels *Wild Flowers in a Long-necked Vase* (Fig. 69) and *White Vase with Flowers* (Fig. 70) are recognizable varieties picked from the garden of the house in the Paris suburb of Bièvres that he inherited in 1909. Three-dimensional form returns, but Redon does

not capitulate to the material world. He accomplishes the remarkable feat of overcoming the antagonism between the spiritual and the physical which had always haunted his work. He need no longer fear the intrusion of reality because it is not now at odds with the artistic order he wishes to create. He has learned to incorporate lucid design and marvellous harmonies of luminous colour within an objective mode of vision. And in consequence the breath-taking effects he creates are yet more magical, because far from excluding the natural world, they occur in the presence of reality. The essential nature of these flowers is, it seems, revealed to us, is clarified and made yet more actual and apparent to the senses.

What Redon achieves in the late flower-pieces needs to be emphasized because it demonstrates that the mysterious in his art does not necessarily depend upon fantastic imaginings or a distortion of reality. He himself rated these works highly. Over half of the paintings and pastels he chose to show at Durand-Ruel's in 1906 were of flowers, and until his death in 1916 they continued to constitute a major part of his production. For Redon, as for Monet at Giverny, garden flowers provided the subject for dozens of pictures and it could be argued that in old age, after a lifetime pursuing opposite goals, these artists finally arrived at the same point. Although their luminous colour harmonies describe much more than physical appearances, both Redon and Monet sought to render the sensations they experienced in long and close contemplation of nature. And so we return full circle to Redon's claim that his originality consisted in placing the logic of the visible at the service of the invisible. 'Nature',

67. *Flowers in a Green Vase*. About 1905. Oil, 27.3 × 21.6 cm. (10¾ × 8½ in.) Pittsburgh, Museum of Art, Carnegie Institute

76

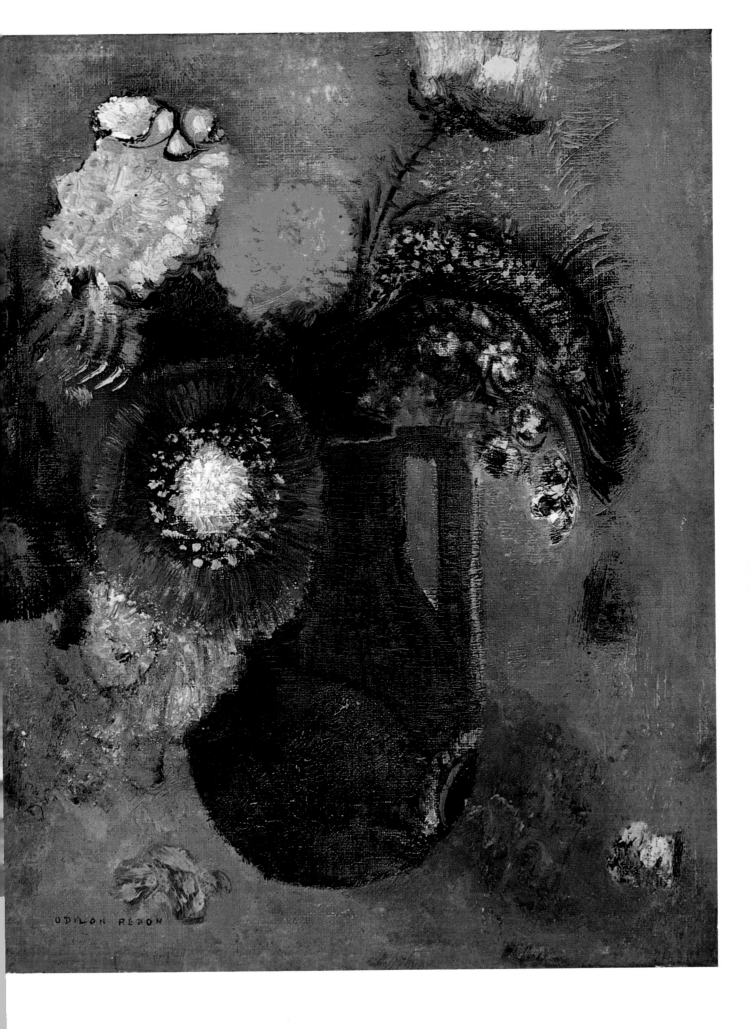

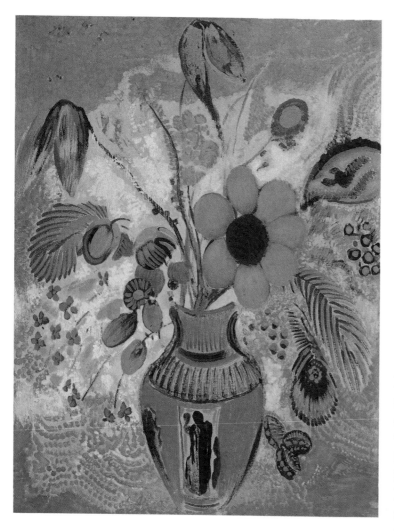

he said, 'becomes my source, my catalyst, my ferment.' He was astonished in 1904 to discover in the writings of Leonardo da Vinci a confirmation of this idea, to find that this artist whom he had long admired had instructed his pupils always to render the ideal in terms of the natural, the known.

Despite his involvement with literary Symbolists, and their support of his art, Redon succeeded in creating a suggestive art which requires no translation into literary terms, which depends on visual imagery derived from sight and imagination.

This art can only be described as Symbolist if the word is understood to denote a type of resonance arising directly from the visual terms in which the artist renders his sensations. *Confidences d'Artiste*, the account of his own life, opens with this assertion: 'I have made an art of my own. I have made it with my eyes open to the wonders of the visible world, and, whatever people may have said, endeavouring constantly to obey the laws of nature and of life.' In both the graphic and colour works Redon offers us a new way of seeing the natural world not dependent upon doctrines and ideas; and the part he plays at the end of the nineteenth century in the evolution of a more penetrating vision of reality is no less crucial than that of Gauguin, Van Gogh or Cézanne.

Opposite: 69. *Wild Flowers in a Long-necked Vase*. After 1912. Pastel, 56.8 × 34.9 cm. (22⅜ × 13¾ in.) Paris, Louvre (Cabinet des Dessins)

Overleaf: 70. *White Vase with Flowers*. 1916. Pastel, 73 × 54 cm. (28¾ × 21½ in.) New York, Museum of Modern Art (Gift of William S. Paley)

68. *Etruscan Vase*. About 1910. Tempera on canvas, 81.3 × 59.1 cm. (32 × 23¼ in.) New York, Metropolitan Museum of Art (Lillie P. Bliss Collection)

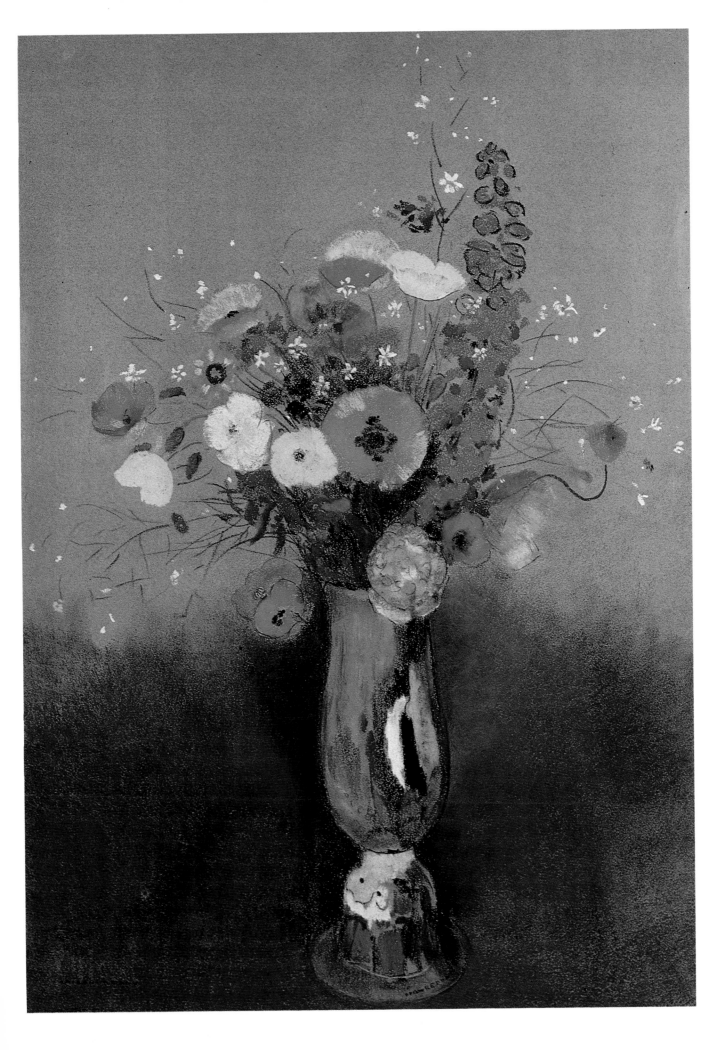

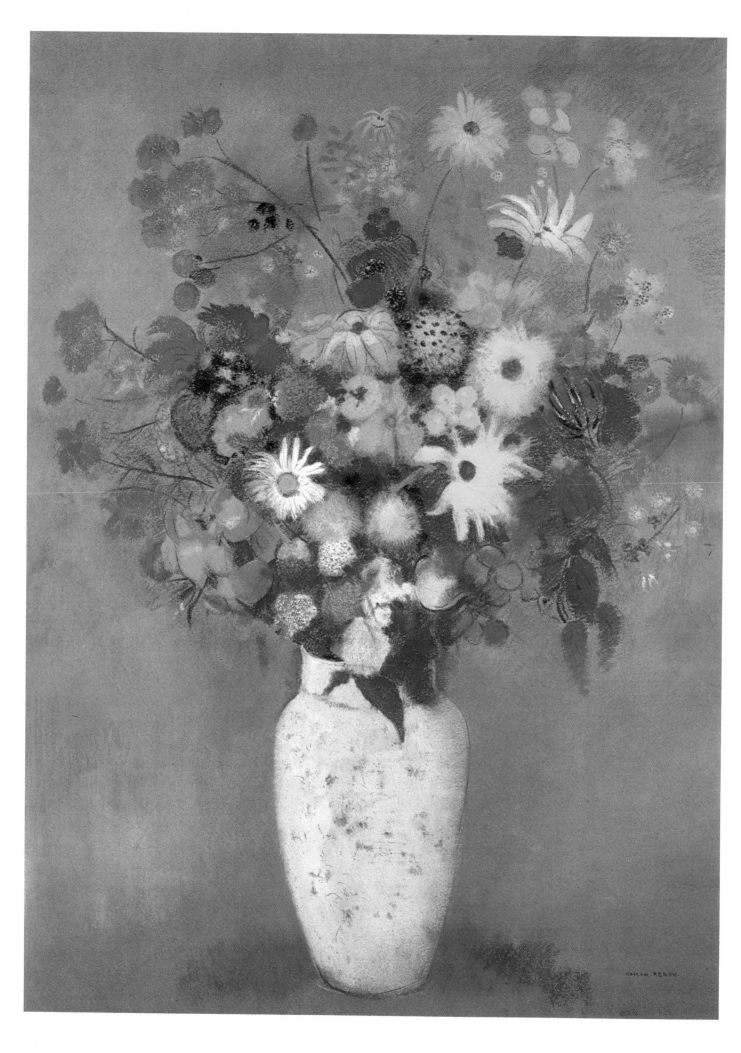